KENNETH T. JACKSON

WWII & NYC

To Holden,
Fellow lover of New York,
Kenneth Jackson

NEW-YORK
HISTORICAL
SOCIETY
MUSEUM & LIBRARY

SCALA

I am fortunate in having had the privilege of being one of the earliest readers of Professor Kenneth T. Jackson's essay, written to accompany the New-York Historical Society's 2012–13 *WWII & NYC* exhibition. It is a fascinating, instructive, and often astonishing portrayal of New York as a city that was central to a war fought thousands of miles away. It will be a revelation to most readers, whether from New York or elsewhere.

A person who was twenty-one years old when the Wehrmacht struck Poland in 1939 will be ninety-four in 2012–13. Soon, the personal memory of New York's role in World War II will be lost. And yet the story of our city's part in the war and the real stakes of New Yorkers in it— with networks linked to perpetrators as well as victims— is a critical part of our history. Between 1942 and 1945, New York was the major port of embarkation for North Africa and Europe, the home of the busiest shipyard in the world, the great harbor where ships loaded with troops and supplies to Great Britain formed into convoys, the center of the Allied propaganda effort, the starting point for the super-secret effort to build an atomic bomb (called, appropriately, the Manhattan Project), the place, more than any other, where the end of war was celebrated, and the port which welcomed more returning soldiers to their homeland than any other harbor.

What's more, the story of how America's great metropolis organized for war continues to resonate today, with lessons learned that help our still heavily immigrant and cosmopolitan population face difficult challenges, such as how to handle perceived security threats from internal and external enemies, and how to reconcile entrenched prejudices with demands for equality, among others.

I thank Professor Jackson, who is both a great historian and my predecessor as President of the New-

York Historical Society, for his work on this project. I am indebted as well to Marci Reaven, New-York Historical's Vice President for History Exhibitions and *WWII & NYC*'s extraordinarily talented curator. Mike Wallace, Pulitzer Prize-winning author of *Gotham: A History of New York City to 1898,* and scholars Martha Biondi, Joshua Freeman, and Jeffrey Gurok, who all contributed content and advice. I am deeply appreciative to them for their help. We are grateful to Joan Davidson and Furthermore for support of this publication. Finally, none of our work at the New-York Historical Society would be possible without the support of our trustees. What great fortune to be able to count on the generosity of our Chairman, Roger Hertog, and our Executive Committee Chairman, Richard Gilder. I am thankful also to our Vice Chair Pam Schafler and to the entire New-York Historical Society Board.

—**LOUISE MIRRER**, Ph.D.
President & CEO
New-York Historical Society

CURATOR'S NOTE

WWII & NYC, the New-York Historical Society exhibition created in tandem with this book, examines how greater New York and its residents confronted the challenges of war mobilization and contributed to the national war effort. The three-thousand-square-foot exhibit, mounted from October 2012 through May 2013, features over four hundred objects and images from the collection of the New-York Historical Society and from institutions around the country.

WWII & NYC's opening display transports visitors back to 1938, as a CBS radio broadcast announces Hitler's march into Austria. This first section of the exhibit covers the years 1933–41 and recreates the noisy contest of opinions in New York over whether the U. S. should involve itself in the war. It also brings visitors to the campus of Columbia University, where scientists conducted top-secret research to develop the atom bomb. Their research marked the beginnings of the Manhattan Project, which derived its name from its city of origin.

After Pearl Harbor and the U. S. entry into the war, New York became the country's leading port of embarkation. The second section of the exhibit, covering the years 1942–45, examines how the city mobilized for war, as industries converted to wartime production and huge terminals surrounding the port shipped men and supplies to Europe. Life changed dramatically on the home front. Civilians encountered new, challenging, and sometimes terrifying experiences, while men and women in uniform filled the city streets. The third section of the exhibit follows New Yorkers to war, with displays on the WAVES and the Signal Corps and stories of individuals who served. A rarely seen documentary film by Signal Corps cameraman Francis Lee traces his journey from New York to Berlin and back. The concluding section

of the exhibit captures scenes of the war's end with the surrender of Germany and Japan. Benjamin Bederson, a young New York soldier who worked on the atomic bomb, reads on film from his diary entry written as the Enola Gay was flying toward Hiroshima.

Professor Bederson's interview is one of thirteen short films made especially for the exhibition by Ducat Media. The films explore such topics as the Brooklyn Navy Yard, the confinement of enemy aliens on Ellis Island, and the rise of a northern Civil Rights movement in response to wartime racial discrimination.

It was my great pleasure to work with Professor Kenneth Jackson who served as chief historian on *WWII & NYC*. Sincere thanks to Dr. Louise Mirrer for her leadership and vision; to my New-York Historical colleagues for their stellar work; and to the historians, collectors, curators, and institutions that shared their deep expertise with us and lent important objects. We owe a special debt to Joseph Meany, to Kenneth Rendell of the Museum of World War II, and to historian Mike Wallace who graciously shared his chapters from the in-progress *Gotham II: A History of New York City from 1898 to 1945*. And we are deeply grateful to the veterans and other wartime participants and their families who generously and to great effect shared their photographs, mementos, and moving accounts of their experiences.

— **MARCI REAVEN**, Ph.D.
Vice President for History Exhibitions
New-York Historical Society

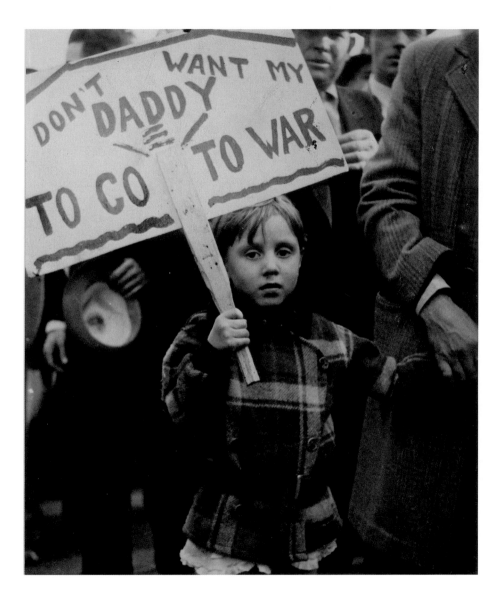

KENNETH T. JACKSON

I'll Be Seeing You

New York City During World War II

When most people think of World War II, they conjure up images of battleships and bombers, of tanks and heavy artillery, or of helmeted soldiers and marines wading through surf and machine gun fire to establish a beachhead on a contested landing site. If they consider the role of cities at all. it is usually as targets—London under the Luftwaffe blitz, Dresden being firebombed, or Hiroshima melting under the atomic bomb.

This book and exhibition are about a particular city during the greatest conflict in human history. But it was not an ordinary place. New York was the largest metropolis and had the busiest harbor in the world, and its soldiers and factories, its shipyards and piers, and its research laboratories and scientists played a formidable role in achieving victory over Germany and Japan. The troopships and convoys that sailed for Europe left for the most part from its docks, and it was to those same docks that the soldiers returned after victory was won.

In the short term, the war stimulated the local economy and highlighted the city's centrality to the American military machine and Allied victory. In the long term, however, New York lost population, industry, and economic significance to other parts of the nation. During the battle

Opposite:
Memories of the carnage of World War I and the desire to focus on social change at home led many Americans to say that the U. S. must stay out of yet another European war.

David Robbins (1912–1981), *Antiwar Demonstration (Don't Want My Daddy to Go to War)*, c. 1941. Gelatin silver print. Columbus Museum of Art, Ohio: Photo League Collection, Museum Purchase with funds provided by Elizabeth M. Ross, the Derby Fund, John S. and Catherine Chapin Kobacker, and the Friends of the Photo League, 2001.020.117

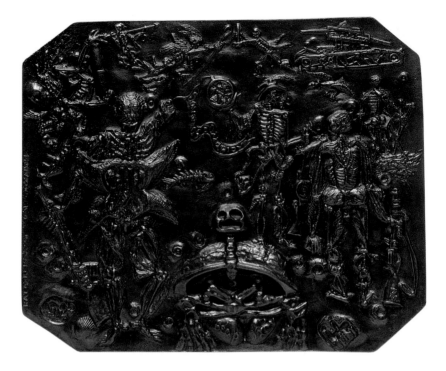

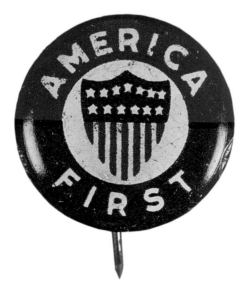

against Hitler and Hirohito, the federal government funded huge new factories and military bases in the South and West, far from the congested boroughs of New York. After the war, the city's industry could not compete. Not until the end of the century, when the city reinvented itself as the headquarters for America's new service economy, did the metropolis once again solidify its standing as the capital of capitalism and the capital of the world.

World War II began on September 1, 1939, when the German Army crossed the Polish frontier. Adolf Hitler previously had swallowed several smaller neighbors, and this latest aggression was the last straw for Great Britain and France, both of which promptly declared war on the Third Reich. But the governments in London and Paris were unable to provide effective military aid to the Polish people, and in any case, the Red Army of the Soviet Union soon invaded the hapless country from the east. Effective resistance by Poland soon ended.

The larger war continued, however, so that for the second time in a generation, Europe became a killing field. What would the United States do? From a twenty-first-century perspective, it would seem inevitable that America would be engulfed by the most terrible conflict in human history. But it did not seem inevitable in 1939. At that time, the American people were staunchly opposed to any involvement in the conflict. They remembered that World War I had not actually ended international violence, and they remembered as well that many of the stories about the German "rape of Belgium" in 1914 had turned out to be mainly British propaganda. It seemed that the only people to profit from the war were financiers, munitions makers, and arms merchants. So why make the same mistake again? One campaign against American involvement in this latest of European wars was called "America First." Led by Charles H. Lindbergh (the pilot who became famous for his daring transatlantic solo flight from New York to Paris in 1927), America First thrived in the Midwest. On May 23,

Above & above right:
Throughout the twentieth century, New York was home to people of enormously varied national and religious origins, who formed ethnic enclaves within the larger city and maintained close ties with their home countries.

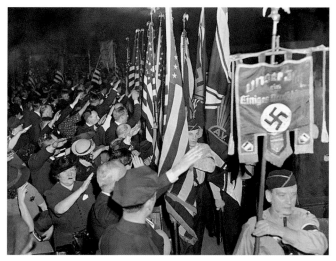

Above:
Members of the German American Bund show their support for the Nazi cause, saluting the swastika during a rally at Madison Square Garden on February 20, 1939.

1941, "Lucky Lindy" came to New York to headline a giant rally at Madison Square Garden to keep the United States out of the war.

As European nations took sides, with Germany, Italy, Spain, and a few small neighbors to the east on one side, and the Allied nations of Great Britain (with its Commonwealth), France, Denmark, and the Netherlands on the other, there was no consensus in New York on the relative merits of the opposing forces. The city at the time was in the midst of a giant World's Fair. On the exact day that Hitler's legions attacked Poland, the fair featured a concert by the Harry James Orchestra and an exhibition by the Seventh Cavalry practicing armored maneuvers. In fact, when the fair closed two months later, it had attracted a phenomenal 44.9 million visitors.

If the World's Fair unified New Yorkers, the world war divided them. After all, the city had huge German-American, Italian-American, and Irish-American neighborhoods where there was little sympathy for the Allied cause. For centuries, Irish Catholics had felt oppressed by their absentee English rulers, while German enclaves and Little Italy embraced the notion that Adolf Hitler and Benito Mussolini had restored confidence and pride to their respective homelands. The German-American Bund, which advocated for the Nazi cause, had its headquarters on East 85th Street. It was led by a German-born chemist who had immigrated to America in the 1920s, and it gained nationwide attention when the Bund held a big rally on February 20, 1939 in Madison Square Garden. Swastikas, not yet the loathsome symbols they would later become, occasionally could be seen in the shop windows in Yorkville on the Upper East Side of Manhattan. After the Nazi surrender, Hollywood produced a fictionalized account of the FBI cracking a real German spy ring and set the film on the Upper East Side, calling it *The House on 92nd Street* (1945).

At the same time, Jewish-Americans worried about the attacks on Jews and escalating repression within the Third Reich and about new laws in Nazi Germany that limited Jewish access to the professions. They realized

POLICE DEPARTMENT
FIGHT FOR FREEDOM

CLASSIFICATION

WANTED FOR MURDER

ADOLF SCHICKLGRUBER
Alias Hitler

Wanted for MURDER; ARSON; GRAND LARCENY; POSSESSION OF FIRE-ARMS; PIRACY; TREACHERY; RELI-GIOUS PERSECUTION.

SHOOT ON SIGHT!

REWARD!

DESCRIPTION—Age, 52 in 1941; height, five feet, seven inches; weight, 150-165; hair, black, shaggy locks hang over forehead; eyes, black, have demented gaze; complexion, sallow; football mustache, eleven hairs on each side; foppish dresser, but has marked devotion to brown shirts and an old trench-coat.

PARTICULARS—This man has tendency to become hysterical on slight provocation, has been known to throw himself on floor and gnaw rugs; guttural voice apt to rise to shrill tones when excited or thwarted. He has delusions, particularly about his place in history and his powers over vast numbers of people. He is sadistic, malicious, bombastic, vengeful, mystical, maniacal, addicted to public hysteria on "race purity;" suffers from dreams of persecution. He is a congenital liar. He has worked at only one known trade — house painting.

RECORD—He has served one term in prison, and has a police record of inciting to riot in various cities.

This man is dangerous, will attack without warning; he is always surrounded by armed thugs and expert gunmen.

If captured, dead or alive, the reward will be freedom for the entire world and peace for all nations.

NOTIFY

FIGHT FOR FREEDOM, INC.

1270 SIXTH AVENUE. NEW. YORK CITY TEL. CIRCLE 6-4250

118

that Washington would have to act if the Nazis were to be stopped, and they favored intervention on the side of the Allied nations. They fought the America Firsters and the German-American Bund with their own rallies and displays of American patriotism. Other liberal groups also favored the Western democracies because of the repressive politics of Fascist Italy, militaristic Japan, and Nazi Germany, which collectively had become known as the Axis powers.

President Roosevelt was not conflicted. He favored the Allied cause from the beginning, and he carefully moved his nation to a state of greater military preparedness. On July 19, 1940, Congress authorized the largest shipbuilding program in American history, one that aimed to double the size of the United States Navy. Army Chief of Staff George

Oppcsite:
Fight for Freedom, Inc. was an interventionist group whose high-profile leaders forcefully promoted American involvement in the war. Flyers such as this were among the group's many propaganda tools.

Above:
On September 16, 1940, FDR signed the Selective Training and Service Act into law, establishing the nation's first peacetime draft.

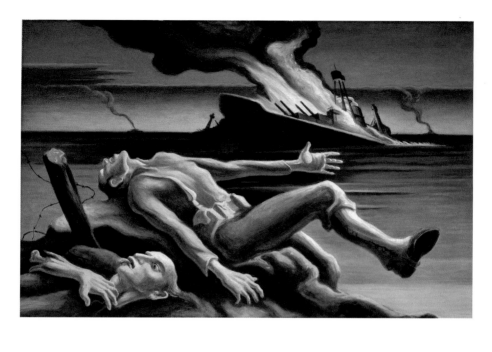

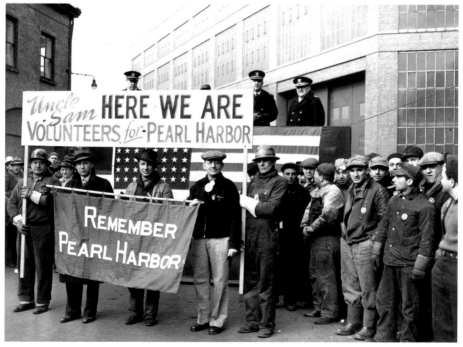

C. Marshall supervised an enormous expansion of the nation's ground forces, a program enhanced by the initiation of America's first peacetime draft on September 16, 1940 and the federalization of the two-hundred-seventy thousand members of the National Guard.

War Comes to New York

On December 7, 1941, Japanese airplanes launched a surprise Sunday morning attack on the United States Pacific Fleet at its anchorage at Pearl Harbor in the Hawaiian Islands. The skilled pilots of the Rising Sun disabled or sank all eight American battleships in port and killed more than 2,400 sailors, soldiers, and civilians. The next day, a resolute FDR spoke of the attack as "a day which will live in infamy" and asked a joint session of Congress for a declaration of war against Japan. On December 11, Germany declared war on the United States, even though Hitler's defensive agreement with Japan did not require the Third Reich to act unless Japan were the victim, not the aggressor.

When the United States entered the war, New York was the largest city in the world, with more than seven million residents in the five boroughs and another four million in the nearby suburbs. Even during the Great Depression, New York's harbor was the busiest, its skyscrapers the tallest, its land values the highest, and its industrial output the greatest of any city in the world. Fifth Avenue already was synonymous with shopping, Broadway with theater, Madison Avenue with advertising, and Wall Street with finance. The great radio networks and publishing empires were all headquartered in Manhattan, and the New York Stock Exchange was the financial world's dominant trading floor.

Once war was declared, residents of the city faced the unknown. They had read in newspapers and listened on radios about the Luftwaffe blitz on London in the fall of 1940. Would American coastal cities—New York chief among them—become targets for bombing? What about

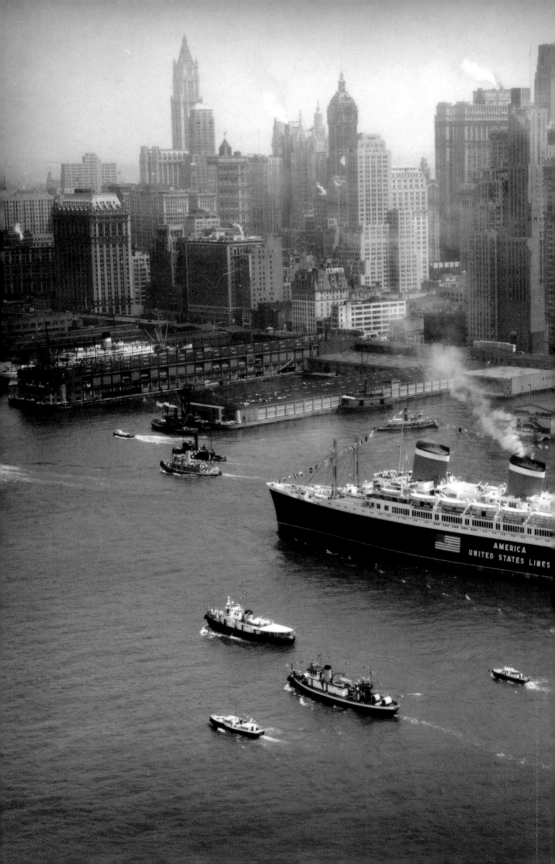

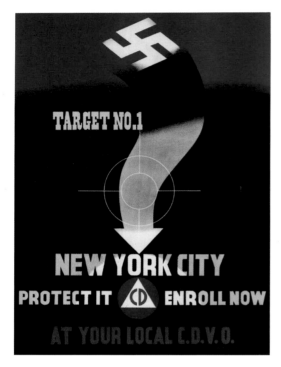

TARGET NO.1

NEW YORK CITY

PROTECT IT **⟨CD⟩** ENROLL NOW

AT YOUR LOCAL C.D.V.O.

Above:
This poster, designed by the influential graphic artist E. McKnight Kauffer, highlights the sense of fear and urgency that descended upon the city after Pearl Harbor. Although New York never saw battle, the city mobilized itself for war.

Opposite:
In the North Atlantic, an American transport ship is blown up by a German U-boat. Over the course of the war, 3,675 ships—both merchant and naval—were lost in the Atlantic.

submarine attack? After all, German U-boats—Hitler's fleet of attack submarines—had already been waging a relentless undersea war against Atlantic shipping, and they would presumably redeploy to American waters to attack defenseless oil tankers and cargo ships along the East Coast, crippling American supply lines.

Initially, the Empire City did seem vulnerable. Although German bombers never had the range to reach the United States, U-boats could reach New York, and during the first four months of 1942, enemy undersea vessels sank eighty-seven ships in the Atlantic. One of the first victims was the *Coimbra*, a British tanker transporting American oil to Britain. On January 15, 1942, thirty miles off Long Island, she was sunk by a single torpedo from a U-boat, and the captain and thirty-five crewmen perished; only six injured survivors were rescued from the freezing waters of the Atlantic.

New Yorkers quickly adapted to the mobilization that war demanded. Thousands of volunteer aircraft spotters and air raid wardens turned out for duty twenty-four hours a day. On June 13, 1942, a giant "New York at War" parade saw five hundred thousand participants march up Fifth Avenue from Washington Square to 79th Street. It took eleven hours for all the civilians and members of every service to pass in front of more than two million cheering onlookers. Two days later, Mayor La Guardia told radio listeners in his weekly program that he would go to Washington to demand more war contracts; the city, he said, had vast resources to support the war, including millions of square feet of empty factory space, tens of thousands of

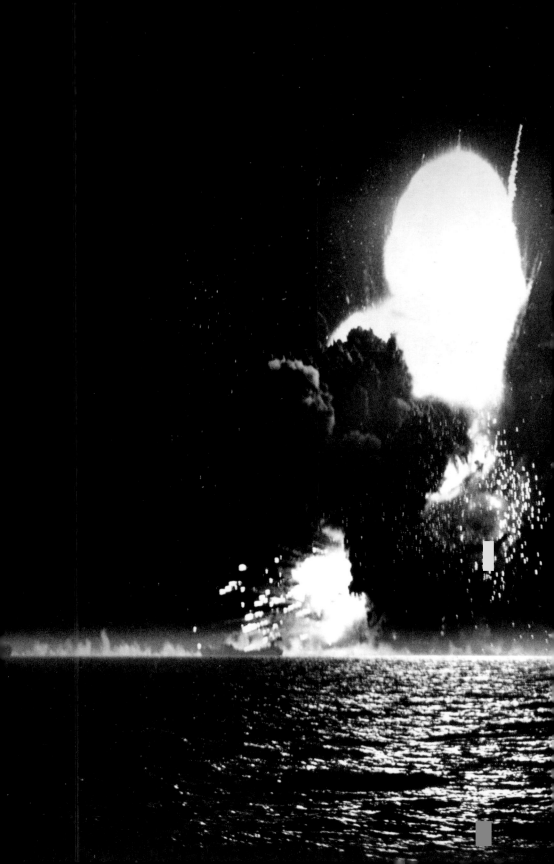

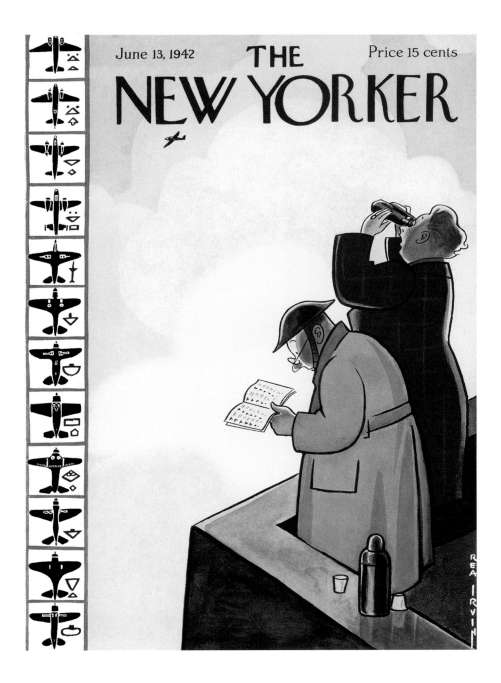

June 13, 1942

THE NEW YORKER

Price 15 cents

vacant apartments, and three hundred thousand unemployed workers.

With the entrance of the United States into the war, the military presence in and around the city grew dramatically. Bases like Floyd Bennett Field and Fort Hamilton in Brooklyn, Fort Dix in New Jersey, Fort Wadsworth on Staten Island, Fort Tilden in Rockaway Beach, Fort Hancock on Sandy Hook, and Camp Smith to the north all expanded swiftly. The Navy established the Eastern Sea Frontier, under the command of Vice Admiral Adolphus Andrews from his headquarters at 90 Church Street in Manhattan, to monitor ship movements along the coast. It also installed a submarine net between Staten Island and Brooklyn to prevent incursions by U-boats into the harbor. Coastal artillery batteries went up along the south shore of Brooklyn, the east side of Staten Island, and on the edges of Long Island Sound. Fortunately, they never were forced into action.

The only real Axis test came in the early morning hours of June 13, 1942, when a U-boat took advantage of fog and landed four German saboteurs on the beach at Amagansett, Long Island. Carrying four crates of explosives and $84,000 in cash, they were instructed to wait six weeks and then begin to destroy American war-making facilities. Unfortunately for the saboteurs, a Coast Guardsman patrolling the beach spotted them soon after they had buried their uniforms and detonators. In desperation, they paid the beach patrolman $260 to buy his silence. They took an early morning commuter train to Manhattan, while the Coast Guardsman immediately reported the incident to his superiors. The hunt was soon under way.

Trying to blend in with the millions of other people in the great city, the four conspirators took a room on the Upper West Side, mingled with other sightseers at Grant's Tomb, walked around Columbia University, shopped at the Rogers Peet men's store on Fifth Avenue, listened to jazz, and visited a brothel. Despite their infiltration, the saboteurs never blew up anything. They were caught (along with four accomplices who had come ashore in Florida)

Opposite:
With the entry of the U. S. into the war, New Yorkers of all ages kept vigilant watch for enemy aircraft. In June 1942, the *New Yorker* humorously depicted a couple on their rooftop, diligently doing their bit.

Irvin/ The New Yorker/ Condé Nast Archive © Condé Nast

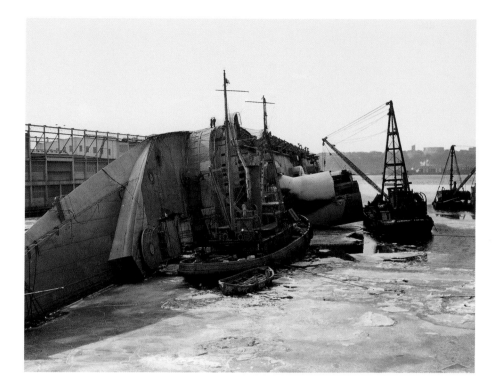

After catching fire on February 9, 1941, the SS *Normandie*—having been pumped full of water by the fire department—capsized at her berth.

after two of them traveled to Washington and confessed to the FBI. President Roosevelt ordered a closed military trial for the Germans. All were sentenced to death; FDR commuted the sentences of the two who had confessed; the remaining six were executed on August 8, 1942.

Although sabotage remained a real threat, not all losses came at the hands of the Axis. On February 9, 1942, the SS *Normandie,* the most luxurious ocean liner in the world, was moored at Pier 88 on the West Side. Once the property of France, which was at this point occupied by Germany, the ship had been confiscated by the United States after the war began and rechristened the USS *Lafayette* for the purpose of taking American troops to Europe. The ship caught fire during its conversion when sparks from a welder's torch allegedly ignited a pile of life vests. Several fireboats and dozens of fire companies were on the scene within minutes. But the flames were not eas-

ily extinguished, and the firefighters poured so much water into the vessel that, in the early hours of February 10, it capsized at its berth.

You're in the Army Now

The Army's recruiting office at 39 Whitehall Street in lower Manhattan became one of the busiest such facilities in the United States as New Yorkers, like their countrymen across the land, joined the service to defend their country. Between 1942 and 1945, more than a million persons in the metropolitan region served in the armed forces, and military uniforms became ubiquitous on city streets. The New York area became a major center for training as well. Roughly twenty-four thousand men were graduated from the U. S. Naval Reserve Midshipmen's School at Columbia University, meaning that more officers were trained in New York during World War II than at the Naval Academy in Annapolis. The Navy's Women Accepted for Volunteer Emergency Service (WAVES) had its most important national training site at Hunter College (now Herbert H. Lehman College) in the Bronx, the United States Coast

When the United States entered the war, many New Yorkers rushed to enlist. Here, men sign up at an Army recruiting station in New York.

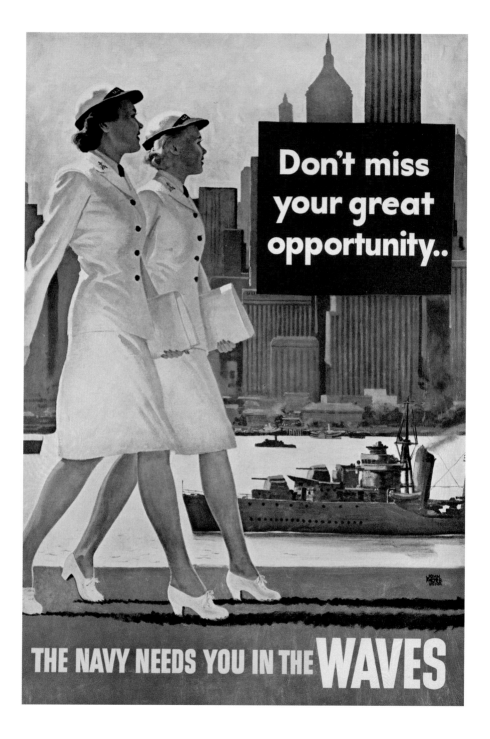

Guard maintained its largest training station at Manhattan Beach in Brooklyn, and two-thirds of all merchant seamen who sailed the Liberty and Victory ships carrying supplies to the front were trained in the city.

The Arsenal of Democracy

The industrial achievement of the United States in World War II was phenomenal by any measure. In 1940, when President Roosevelt issued a call for the production of fifty thousand airplanes per year, it was widely felt to be a pipe dream. Yet by 1944, American factories were producing almost one-hundred thousand airplanes per year—about twice as many as both Germany and Japan together and almost as many as the rest of the world combined. Statistics for jeeps, artillery pieces, self-propelled guns, oil, aluminum, and bombs were equally dramatic. The nation produced so many trucks and shoes that it shared its resources with the British Army and the Red Army, both of which desperately needed them. Meanwhile, America's shipyards produced so many vessels that by the end of the conflict, the United States Navy was not only larger than that of any other nation, but it was larger and more powerful than all other navies in the world combined.

While World War II helped end the Great Depression of the 1930s by providing jobs for the unemployed, New York was slower to come out of the crisis than other industrial cities, and it received smaller war contracts than other places. In part, this reflected the federal policy of favoring big companies because they could ramp up war production faster than smaller companies could. The degree of concentration was startling. Through the summer of 1942, the largest one hundred firms in America had received seventy-three percent of the war contracts by dollar value. But Gotham's twenty-seven thousand factories, ever small, averaged only fifteen employees each, nothing like General Motors, Ford, and the Chrysler Corporation. And New York companies typically were not oriented to

Opposite:
The Women Accepted for Volunteer Emergency Service (WAVES) was established in June 1942 as the all-female branch of the U. S. Naval Reserve. Members served shore duty in the wartime Navy to free male sailors and officers for duty at sea.

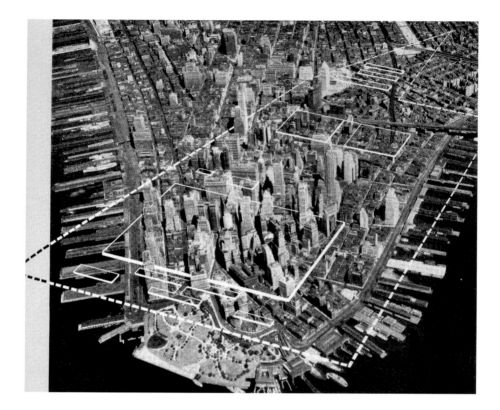

Early in the war, New York's collection of small manufacturers could not compete for defense contracts with heavy industrial producers elsewhere in the country. Here, the outline of Chicago's huge Dodge auto plant dwarfs lower Manhattan.

the production of tanks, rifles, boots, artillery, airplanes, jeeps, trucks, armored personnel carriers, and other major instruments of war. Not surprisingly, Detroit received approximately six times the per capita volume of contracts as New York did, and Newark, San Francisco, Cleveland, and Los Angeles garnered four times as much as Gotham. As a result, New York still had an unemployment crisis as late as 1942, when a special delegation went to Washington to convince federal officials to spend more money in the nation's largest city.

With the delegation's success in Washington, New York's industry grew rapidly. By 1944, there were a record 1.86 million people in manufacturing jobs in the city, of which seven-hundred thousand were war-related; this was at a time when one million men from the area were in the armed services. The year before, almost three hundred

new industrial plants opened in New York between January and April. The products turned out in the city's factories were wide-ranging: airplane parts, metal products, spun glass fibers, optical lenses and prisms, dehydrated foods, bombs, canvas goods, tents, tarpaulins, haversacks, leggings, mattress covers, powder bags, bandages, and life preservers. The Canal Street area was covered with small electrical and metal shops, many of which contracted with the War Department.

The Brooklyn Navy Yard was the busiest such facility in the world. With more than seventy-five thousand employees (versus over fifty-five thousand at the Philadelphia Navy Yard or more than twenty thousand at the Wilmington Shipyard) working seven days a week and around the clock between 1942 and 1945, the "yard" was a world unto itself. Its two-hundred-ninety acres contained seven huge dry docks, forty-seven mobile cranes on tracks, eight piers, two colossal steel shipways, two twelve-hundred-foot-long graving docks, foundries, machine shops, warehouses, a power plant, and a hospital. It was crisscrossed by nineteen miles of paved streets and thirty miles of rails. Pier G was home to the Hammerhead, the largest crane in the world at the time. And just outside the gates were more than eighty supporting factories, which together reduced the amount of materials that needed to be transported there.

The Navy Yard was the foremost builder of battleships in the world, and it produced more of them than Japan during World War II. The USS *Arizona,* which was bombed and sunk at Pearl Harbor—taking more than one thousand sailors to an early death—was built there at the end of World War I. So too was the battleship USS *Missouri,* on whose deck the Japanese formally surrendered on September 2, 1945. In addition, the workers at the Brooklyn Navy Yard built the battleships *Iowa* and *North Carolina* and five aircraft carriers (including the *Franklin D. Roosevelt,* the *Bon Homme Richard,* the *Bennington,* the *Kearsarge,* and the *Oriskany*). They also constructed eight large ships designed to ferry tanks onto the beaches on D-Day.

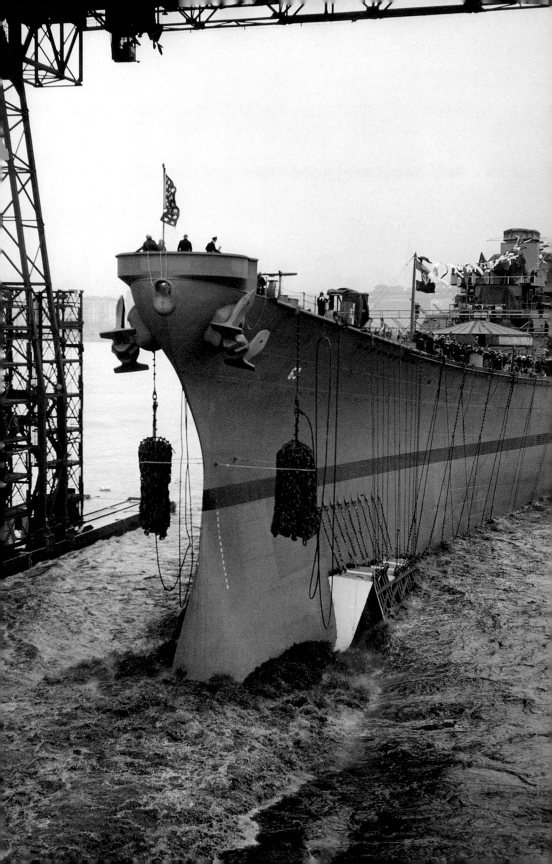

Warships built at other facilities were frequently brought to the Brooklyn Navy Yard to be fitted with guns. More than five thousand other ships were repaired at the yard during World War II, including the Royal Navy battleship HMS *Malaya,* which was refitted in Brooklyn to relieve the pressure on British shipyards.

The Brooklyn Navy Yard was but one of forty shipbuilding and ship-repair facilities in the city. Bethlehem Steel's Staten Island yard built forty-seven destroyers, seventy-five landing craft, five cargo ships, and three ocean-going tugs during the war. Todd Shipyards in Brooklyn's Erie Basin had 19,617 employees in 1943, occupied mainly with building and repairing destroyers. They reputedly could take a vessel that had been badly damaged by a German torpedo and put it back in service in a matter

Opposite:
Early in 1944, the battleship USS *Missouri* is launched from the Brooklyn Navy Yard and slides down the slipway into the East River.

Below:
Brooklyn's Todd Shipyards—one of forty such operations in New York—repaired some three thousand vessels over the course of the war.

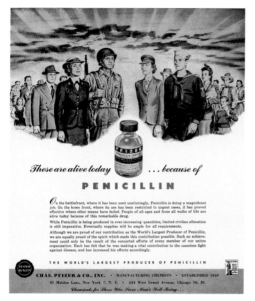

These are alive today ... *because of*

PENICILLIN

On the battlefront, where it has been used unstintingly, Penicillin is doing a magnificent job. On the home front, where its use has been restricted to urgent cases, it has proved effective where other means have failed. People of all ages and from all walks of life are alive today because of this remarkable drug.

While Penicillin is being produced in ever-increasing quantities, limited civilian allocation is still imperative. Eventually supplies will be ample for all requirements.

Although we are proud of our contribution as the World's Largest Producer of Penicillin, we are equally proud of the spirit which made this contribution possible. Such an achievement could only be the result of the concerted efforts of every member of our entire organization. Each has felt that he was making a vital contribution to the ceaseless fight against disease, and has increased his efforts accordingly.

THE WORLD'S LARGEST PRODUCER OF PENICILLIN

CHAS. PFIZER & CO., INC. • MANUFACTURING CHEMISTS • ESTABLISHED 1849
81 Maiden Lane, New York 7, N. Y. • 444 West Grand Avenue, Chicago 10, Ill.
Chemicals for Those Who Serve Man's Well-Being ...

Pfizer's revolutionary advances in the mass production of penicillin saved the lives of countless Allied troops. Pfizer became the world's largest producer of the antibiotic.

of days. Over the course of the war, Todd repaired and refitted some three thousand vessels and built twenty-four landing craft of the type which took American soldiers to the beaches of Normandy on D-Day.

Other New York factories were equally busy with war work. Inside a converted ice plant on Marcy Avenue in Brooklyn, Pfizer—a Brooklyn company founded by two German immigrants in 1849—built the first factory to mass-produce the world's first life-saving antibiotic, penicillin. Having beaten other companies in finding a way to mass-produce the brand-new drug, Pfizer bought the ice plant on September 20, 1943, and quickly converted the factory into the first penicillin factory in the world. Amazingly, within three months of the plant's opening on March 1, 1944, it produced most of the penicillin to go ashore with American troops on D-Day, June 6, 1944. By that date, American penicillin production was one-hundred billion units *per month,* and Pfizer was making more than fifty percent of it. An advertisement of the time depicted four military men and women at the center of a line of civilians. Beneath them, a caption read, "These are alive today... because of PENICILLIN."

The Carl L. Norden Company developed and manufactured the top-secret Norden bombsight for the Army Air Forces, which needed it for bombardiers over Germany and Japan. The Norden Company had its headquarters and major production facility at 80 Lafayette Street in Manhattan and an additional factory at 50 Varick Street. Meanwhile, the Sperry Gyroscope Company in Brooklyn and the Ford Instrument Company in Long Island City were producing other devices to help naval gunnery officers adjust their aim to control for the tossing of the sea.

In Queens, the Steinway Piano Company manufac-

Precision Bombing Pulverizes Focke-Wulf Plant

PROTECTED only by a false security, this huge Nazi plant (above, right) produced almost half Germany's Focke-Wulf Fighters. The factory, which had been moved from Bremen to Marienburg, in East Prussia, was recently the target for one of the most successful American bombing raids of the war. Above, part of the giant fleet of bombers poised above the target, a mass of smoke and flame, staggering under our blows. General H. H. Arnold called this raid "the finest example of precision bombing." Bombardiers, operating the Norden Sight, concentrated their bombs on the relatively small target area.

Photograph taken after the raid (right) shows the plant to have been virtually demolished. Only one building escaped direct hits, and that one was severely damaged by near misses.

The high quality of workmanship that goes into every part of Norden equipment made the extermination of this Nazi plant possible. If our forces were without the Norden Bombsight, which is being produced in ever-increasing quantities by Norden men and women,

this plant might still be producing Focke-Wulf fighters, to attack our husbands, our brothers, our sons.

tured glider wings on behalf of General Aircraft Corporation. On D-Day, these gliders were towed behind regular aircraft and then cut loose over the drop zones in France to take airborne assault troops behind enemy lines. Aircraft parts were made in Long Island City, and the Aluminum Corporation of America built a 101-acre, 1.1-million-square-foot plant along Maspeth Creek that employed ten thousand workers and produced millions of tons of aluminum.

The city's garment industry, long the center of American clothing manufacture, produced a substantial number of military uniforms. The Amalgamated Clothing Workers of America negotiated for Army and Navy contracts to be dispersed among its many union shops in different cities, but New York was assured that its fifty thousand metropolitan-area members would have work. A contract for more than 1.2 million overcoats (valued at $2.8 million) was issued in 1942. New York and Philadelphia shared a contract for one hundred thousand Navy uniforms, and the Army gave contracts for one-hundred-twenty-five thousand garments to shops in Brooklyn and Manhattan. The United

The Norden bomb-sight, manufactured in Manhattan during the war, was designed to allow American bombers to precisely identify and destroy Axis military targets.

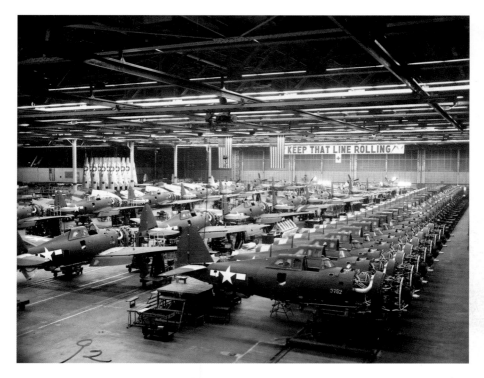

Above:
Inside Republic Aviation on Long Island, rows of P-47 Thunderbolt fighters await final assembly and shipment to the Army Air Forces.

Right:
The movie sets created by the Army in Astoria were as diverse as the films produced there. Here we see a field headquarters in Europe, but the next day's set might show North Africa, England, or Grand Central Terminal.

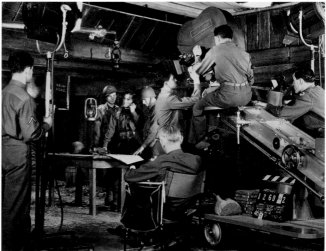

States Naval Clothing Depot, at Third Avenue and 29th Street in Brooklyn, was among the largest and most sophisticated clothing production and distribution plants in the world. Within its walls, over a thousand employees manufactured, packaged, and shipped all the white twill and blue flannel uniforms and auxiliary garments that were worn by the sailors of the entire United States Navy.

In the New York area, heavy industry was located in the suburbs rather than in the city itself. Long Island in particular had been important in aviation history from the time the Wright Brothers first demonstrated the possibility of controlled flight. Republic Aviation's Farmingdale plant made more than fifteen thousand P-47 Thunderbolt fighters, many of which provided air support above Allied armies in Europe. Similarly, Grumman Aircraft Engineering Corporation in Bethpage was the major production center for the Navy's Hellcat fighter planes and Avenger torpedo bombers. And in New Jersey, the Curtiss-Wright Company made aircraft engines and propellers in Caldwell and Paterson.

Many of the metropolitan area's contributions to Allied victory were intellectual and psychological rather than physical. The city's media prowess was tapped in the service of the war effort. From the former Paramount Studios lot in Astoria, Queens, the Army Pictorial Service made military training films and instructed combat cameramen and photographers. At its peak it had both military and civilian employees, including famous New York and Hollywood filmmakers, the most renowned of whom was John Huston, director of *The Maltese Falcon*. Particularly moving was the story of Harold Russell, a demolition expert who lost his hands. To inspire other maimed soldiers, he was the focus of a film made in Queens called *Diary of a Sergeant*. Russell later became better known when he starred in the 1946 Hollywood film *The Best Years of Our Lives*.

But New York's most important contribution to the war effort remained a secret until long after the final surrender. The development of the atomic bomb began in the Pupin Physics Laboratories of Columbia University,

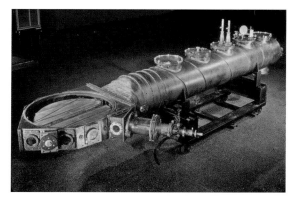

where Leo Szilard and Nobel laureate Enrico Fermi, among others, began experimenting with nuclear fission. The early effort employed a group of physicists at Columbia, while members of the football team helped move hundred-pound packs of uranium. After 1942, the bomb's production was overseen by the Army Corps of Engineers. The Corps named the project the Manhattan Engineer District, believing that following the convention of naming engineering commands for the city in which they were headquartered would avert suspicion. Eventually, even as it moved across the country, the entire undertaking would come to be known as simply the Manhattan Project. Its lead researchers moved to the University of Chicago and then to Oak Ridge, Tennessee, and Hanford, Washington. In Los Alamos, New Mexico, the final development of the weapon occurred, headed by J. Robert Oppenheimer, who had grown up at 155 Riverside Drive on the Upper West Side.

Physicists working at Columbia University's Pupin Hall used this portion of a cyclotron, or atom smasher, in 1939 to demonstrate the potential power of atomic energy. Their work evolved into the Manhattan Project.

Ethnic Trials and Tribulations

Ethnic discrimination continued throughout the war. The worst example of the national failure to provide its citizens with full respect and civil rights occurred on the West Coast, where Japanese Americans, many of whom were citizens by birth, were suspected of being enemy agents. Without due process or legal recourse they were rounded up and sent to makeshift internment camps in remote corners of the American West. The New York metropolitan area had few Japanese, but the region was home to significant German-American and Italian-American populations. It would not have been possible to send all of them to internment camps, but those who had not yet become

citizens were vulnerable and classified as "enemy aliens." The FBI sometimes searched their homes and confiscated radios and telescopes that presumably could be used for espionage. Over the course of the war, the government did detain and intern enemy aliens for suspected disloyalty to the United States, as many as seven thousand of them on Ellis Island, which served as a principal government detention, internment, and deportation center.

Although suspected of no loyalty to the Axis, African Americans suffered from constant, thoroughgoing discrimination. Despite both the urgency of national mobilization and the fact that President Roosevelt had issued an executive order against discrimination in defense industries and government, the color line still applied. Blacks rarely were allowed to serve in the Navy or the Marine Corps, and in the Army, they were typically relegated to segregated units, led by white officers, and most often

During the war, the U. S. government detained, interned, and deported non-citizens, or "enemy aliens," from Germany, Italy, and Japan who were suspected of disloyalty to the nation.

Right:
A. Philip Randolph, head of the Brotherhood of Sleeping Car Porters, called for a mass march on Washington on July 1, 1941 to pressure the U. S. government to abolish racial discrimination by employers. Ā week before the intended date of the march, FDR issued Executive Order 8802, which called for fair hiring in government jobs and the defense industry.

Opposite:
Police officers line up on West 123rd Street on August 2, 1943, during the Harlem riot. At one time during the riot there were six thousand police officers on duty in the neighborhood.

CALL to NEGRO AMERICA

——— ALL OUT! ———
NATIONAL NEGRO DAY
FRIDAY, JUNE 27

CELEBRATE THE NEGROES' ACHIEVEMENT
COLORFUL PARADE THROUGH HARLEM!

March On to Washington
———TUES. JULY 1st———

For JOBS In National Defense

Abolition Of Discrimination in Army, Navy, Marine & Air Corps-In Federal and Municipal Governments, Industry & Labor Unions

Mass Meeting · · . TUE. JUNE 27, 8 P. M.
ABYSSINIAN BAPT. CHURCH

Celebration - Entertainment - Dancing
Golden Gate Ballroom Lenox Ave. & 142nd St.

assigned to service rather than combat duties. Their treatment was especially poor on the home front, where they often were refused entry even into official USO clubs. Violence occasionally broke out, the worst incident of which occurred in June 1943 in Detroit, where Belle Isle became a place of racial warfare. And in New York, a riot began on August 1, 1943, at the Braddock, a hotel on West 126th Street in Harlem, when a black woman got into an argument with the white police officer stationed in the hotel's lobby. The officer tried to restrain her, and a black soldier who intervened was shot in the shoulder, spurring rumors that the white policeman had killed him. A riot spread across thirty-five blocks centered on 125th Street and Seventh Avenue, which saw vandalism, larceny, burglary, property damage,

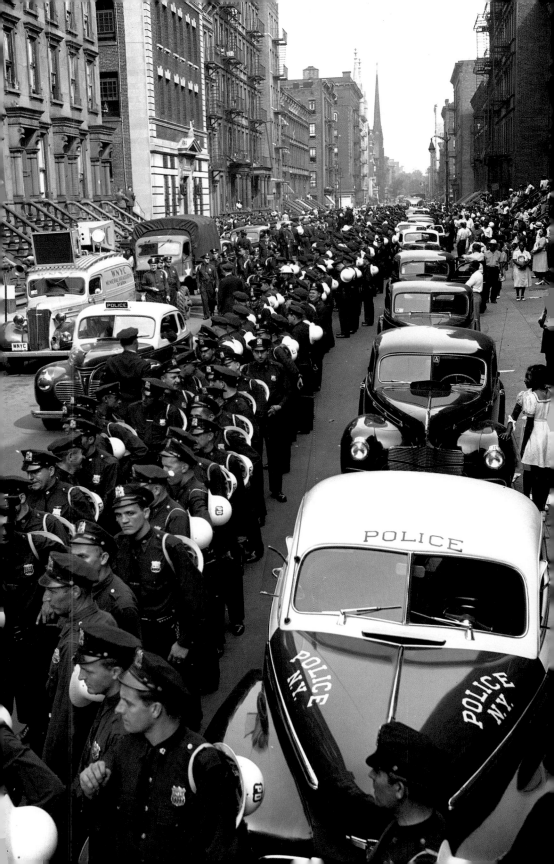

fire, and as many as six deaths. There had been many previous outrages against black citizens and soldiers, and simmering anger aggravated discord into riot. Given the need to mobilize and focus on winning the war, this incident revealed cracks just below the united purpose of the war effort.

The Holocaust

The New York metropolitan region was home to more Jews than any other place on earth. Well before the initiation of formal hostilities with the Third Reich, they had been aware of the repressive laws and violence against Jews instigated by Hitler and the Nazi party. On March 27, 1933, at Madison Square Garden, the Jewish Labor Committee and the American Jewish Congress joined forces to brand "Hitlerism" the gravest menace to peace, civilization, and democracy. The mass meeting of twenty thousand protestors called for an end to the persecution of Jews in Germany, and seventy thousand sympathizers gathered at rallies in Chicago, Washington, San Francisco, and Houston to hear the protest broadcast live from the Garden. At the same time, over one million Americans listened on their radios at home, and a million Europeans tuned in on local stations in Poland, Austria, and Czechoslovakia.

Both the American Jewish Congress and the American Jewish Committee were located in Manhattan, as were most of the smaller organizations. In November 1938, they read with horror of Kristallnacht, when with the German authorities looking on, Nazi paramilitary troopers and civilians killed Jews throughout Germany and Austria, incarcerated thirty thousand in concentration camps, burned over a thousand synagogues, and destroyed at least seven thousand Jewish businesses. On July 21, 1942, the American Jewish Congress, the Jewish Labor Committee, and B'nai B'rith gathered another twenty thousand protestors in Madison Square Garden to publicize the plight of European Jewry and protest the mass killings that by then had

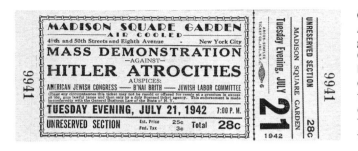

On July 21, 1942, the American Jewish Congress, Jewish Labor Committee, and B'nai B'rith sponsored a demonstration against the Nazis' mass murder of European Jews. Twenty thousand protesters attended.

come to light. In December, important Jewish leaders met with President Roosevelt at the White House, presented him a summary of the graphic and disturbing revelations of Nazi atrocities, and asked that the United States make an explicit threat to the Nazi regime. Roosevelt heard their pleas for action, and on December 17, 1942, the United States, together with Great Britain, the Soviet Union, and eight other nations signed the Allied War Crimes Declaration, which condemned the Nazi regime and promised retribution for its crimes against the Jewish people. Despite these threats, the president did not order American bombers to destroy the rail lines leading to the death camps.

The Logistical Miracle in the Harbor

New York was, in the words of the United States Army, "the mightiest port of war the world has ever known." Because the city was the funnel through which a giant nation poured its material and human resources, the harbor, already the busiest anywhere, became a vast sea of activity during the war years. Over the course of the war, the Army's New York Port of Embarkation grew from a single installation to comprise ten port terminals and three embarkation camps spread around the harbor and throughout the metropolitan region. Oil tankers lined up near the refineries in Bayonne to take on fuel destined for the war against the Axis. The Army Transportation Corps orchestrated everything—a network of highways, piers, ships, and rail lines without parallel. The nation's railroads brought

Soldiers prepare to board a troopship bound from New York for war in North Africa or Europe.

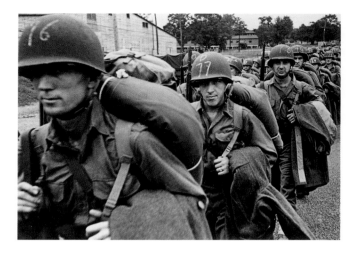

foodstuffs, munitions, and other supplies into the Jersey City rail yards, where the freight cars were then pushed onto barges that were maneuvered by tugboats to one of hundreds of piers. In 1942 alone, even before the big overseas buildup had begun, more than a quarter million servicemen shipped out from New York to Great Britain and North Africa. The human tide grew as the war progressed, and by 1945, well over three million soldiers had passed through the port.

Because New York was essentially the end of the line in the United States, there was a series of staging areas where soldiers prepared for deployment to Europe. The soldiers themselves were processed through one of three embarkation camps: Camp Shanks in Rockland County; Camp Kilmer in New Brunswick, New Jersey; and Fort Hamilton in Brooklyn. The busiest was Camp Shanks, which was located on the west side of the Hudson River in Orangeburg, near the present site of the Tappan Zee Bridge. Camp Shanks was the largest embarkation camp of the United States Army during the war. It covered two-thousand-forty acres and had bunks for 46,875 men. Over the course of the war, 1.3 million soldiers passed through en route to Europe and North Africa. The troops remained there only for a week or ten days, during which time they

received inoculations and prepared their wills. Typically, they also were allowed a twenty-four-hour liberty leave to do as they pleased. Almost all of them used the opportunity to see the bright lights, crowded streets, and nightclubs of the big city a few miles to the south. Finally, they received training in abandoning ship and using lifeboats. As one soldier said, "I guess I feel something like a prizefighter who has trained for the main bout... I'm ready."

A similar routine was followed at Camp Kilmer in New Jersey. For example, the 196th Field Artillery Regiment arrived by train from North Carolina on February 3, 1944 After a week of preparations at the camp, the regiment boarded trains in New Brunswick at 7:30 a.m., arriving in Jersey City two hours later. From there, the soldiers boarded a ferry which took them directly to the United States Army Transport Ship, the *Thomas H. Barry,* by 11:15 a.m. Boarding took almost two days, and the ship left the dock at 9 p.m. on February 11, 1944.

Once overseas, servicemen stayed in touch with their families through the Army Postal Terminal, which had locations at 464 Lexington Avenue and in Long Island City,

Thomas Hart Benton based this canvas on sketches he made in Brooklyn in August 1942, as the first American troops prepared to depart for North Africa.

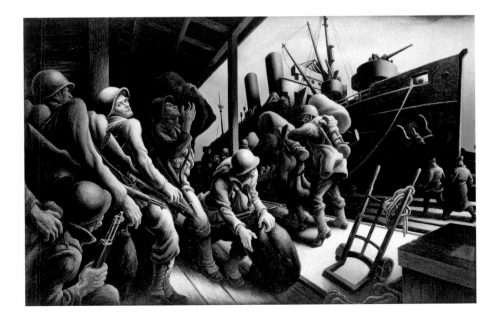

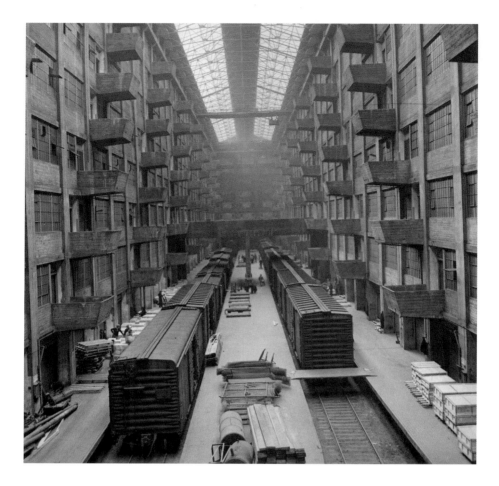

The Brooklyn Army Terminal served as the headquarters of the New York Port of Embarkation. Its Warehouse B included two railroad sidings and 2.2 million square feet of space.

Queens. The Army Postal Terminal handled virtually all of the letters to soldiers, sailors, and airmen in the European Theater. At its peak, the facility processed as many as nine million letters and packages *every day*. And over the course of the war, a reported 3,171,922,000 pieces of first-class mail were sent and received through New York. Then, as now, soldiers in combat zones did not pay for postage.

The transport of millions of men was only part of the logistical miracle that was New York Harbor during the war. The port had 651 miles of active shoreline and more than eighteen hundred wharves, piers, and docks, which could simultaneously berth four-hundred-twenty-five ships. The Port of Embarkation's ten huge terminals included the two-hundred-acre, 1.5-million-square-foot Bush Terminal

in Brooklyn; the Staten Island, Howland Hook, and Fox Hills Terminals in Staten Island; and the North River Terminal, a complex of seven covered piers on the Hudson River around West 46th Street that formed the port's principal embarkation facility. On the New Jersey side of the harbor were the Claremont Terminal in Jersey City and the Port Johnston Terminal in Bayonne, which served as the principal shipping points for combat vehicles, explosives, and ammunition bound for Europe and the Mediterranean.

But the most impressive was the five-million-square-foot Brooklyn Army Terminal. It covered ninety-seven acres and included two giant, eight-story factory buildings with 961-foot-long atriums and four massive piers, each of which could handle several ships at a time. Twenty-four hours a day, long freight trains disgorged supplies and equipment at the New Jersey docks to be loaded onto lighters, small barges which ferried cargoes around the harbor, while seemingly endless lines of trucks rumbled through the streets of Brooklyn, carrying supplies to waiting ships. In total, more than sixty-three million tons of self-propelled guns, artillery pieces, half-tracks, tanks, aircraft, uniforms, C rations, trucks, railroad equipment, and ammunition were loaded onto cargo vessels somewhere in the great anchorage. At the height of the war, the Port of New York handled over four hundred ships per day, when—on average—a ship cleared the port every fifteen minutes.

Every imaginable variety of war materiel flowed through the New York Port of Embarkation to be loaded aboard ships in New York harbor. Railroad equipment was especially in demand, as Allied bombing had destroyed much of the European stock.

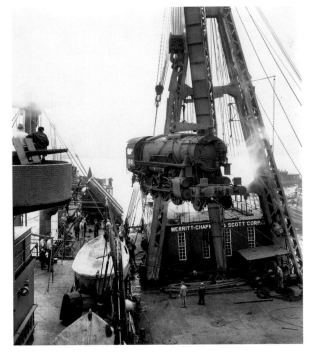

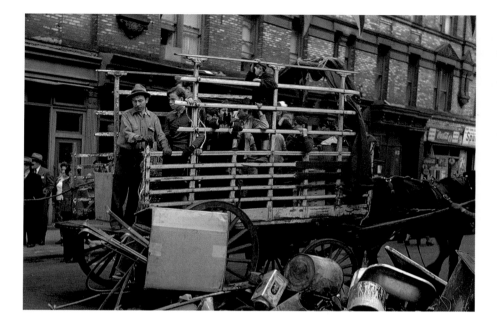

Above:
Civilians collect scrap on the Lower East Side, using a nineteenth-century horse cart to supply the twentieth-century war.

Charles W. Cushman Collection: Indiana University Archives (P02679)

Right:
Posters such as this, issued by the U. S. Office of War Information, encouraged Americans on the home front to support the war effort through thrift and the purchase of war bonds. The blue star in the window represents a family with a loved one in military service.

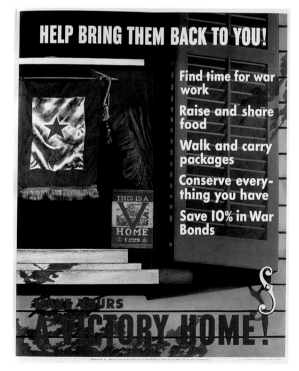

HELP BRING THEM BACK TO YOU!

Find time for war work

Raise and share food

Walk and carry packages

Conserve everything you have

Save 10% in War Bonds

THIS IS A
V HOME

MAKE YOURS
A VICTORY HOME!

Daily Life in Wartime

For the average New Yorker, the war meant rationing, shortages, blackouts, and separations. Meat, sugar, gasoline, eggs, and rubber were in short supply and required coupons for purchase. The Office of Price Administration (OPA) set retail prices for many consumer products and allotted gasoline and heating oil for individual use. Buying war bonds (an $18.50 bond could be redeemed for $25 ten years later), scavenging for precious steel and aluminum, recycling toothpaste tubes and animal fats, cultivating victory gardens, and collecting tin cans became patriotic acts. Proud families posted blue stars in their windows symbolizing husbands and sons who were away in uniform (and gold stars in the event of a death), and housing shortages in the metropolitan area led to the implementation of rent control that has endured into the twenty-first century.

To prevent wartime inflation, profiteering, and hoarding, the federal government instituted rationing shortly after Pearl Harbor. In order to purchase rationed goods, civilians had to trade in stamps from government-issued ration books. By 1945, ninety percent of all goods were controlled.

New Yorkers were at their patriotic best and diabolical worst when it came to rationing. Tires, in short supply because rubber was used for war purposes, were stolen in significant quantities. In March 1942, eighty-five tires were stolen from a single gas station in Coney Island. By May 1942, sugar rationing hit the city, and Mayor La Guardia reminded New Yorkers they had to register for their ration books at local schools, pressing into service eighty thousand volunteers, mostly teachers, to assist with the task. Rationing continued for the remainder of the war.

New Yorkers often felt that if the city played a distinctive role in war, it deserved special consideration. The Society of Restaurateurs asked that New York be classified as a military and war production area because the population was "made up predominantly of beef-eaters..." including so

481706 CU
UNITED STATES OF AMERICA
OFFICE OF PRICE ADMINISTRATION

WAR RATION BOOK FOUR

Issued to _Juan P. Castellanos_
(Print first, middle, and last names)

Complete address _____ _11 W 89 St_
N Y C

READ BEFORE SIGNING

In accepting this book, I recognize that it remains the property of the United States Government. I will use it only in the manner and for the purposes authorized by the Office of Price Administration.

Void if Altered _____
(Signature)
It is a criminal offense to violate rationing regulations.
OPA Form R-145 16—35570-1

many servicemen. In 1945, the city requested exemption from tobacco rationing, saying it was unfair and would never work. To offset price gouging, the OPA demanded that a cup of coffee cost no more than a nickel; it sent out hundreds of women volunteers across the five boroughs to check restaurants and required anyone charging the outrageous price of ten cents to file a statement with the local war rationing board. The city's Markets Department was busy issuing summons to violators of food price ceilings and rationing rules; in one week in 1943, more than six hundred summonses were issued.

In June 1942, the *New York Times* advised New Yorkers to holiday at home: given the gas and tire rationing, and lack of rail, bus, and ship transport, New Yorkers were well advised to stay local. "The native Gothamite has not heretofore regarded his home city as a suitable Summer resort," but times had changed. A cocktail at the Empire State Building would be dandy; a tour through the twelve acres of Rockefeller Center buildings "bathed in romantic blue lights...[would] offer a new setting for soft conversations." New Yorkers heeded the call, and New York restaurants experienced an unprecedented boom in business, as the number of people eating out surged; by 1943, more than one million meals were taken daily in Times Square alone.

On the Town

Soldiers pouring onto the streets of New York while on leave were awed by the buildings touching the sky, the traffic, the noise, the glamour, and the mystery. The city offered a kind of freedom or anonymity that was unknown in small-town America. To escape the sadness, longing, and loneliness that accompanied the war, soldiers, as well as their families, found comfort and diversion in local entertainment. Gotham's famous nightclubs, dance halls, and theaters were home to some of the most famous bands and performers in the world. Billie Holiday, Ella Fitzgerald,

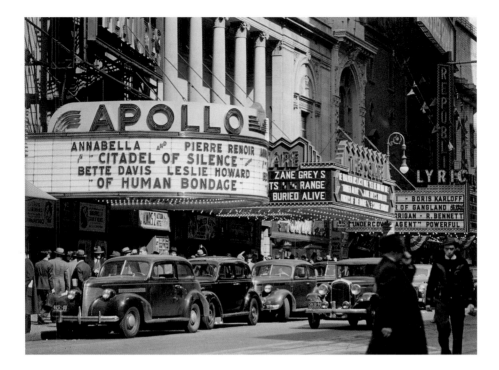

the Andrews Sisters, Jo Stafford, and Peggy Lee could be heard singing the popular songs of the early 1940s, such as "I'm Getting Sentimental Over You," "Till We Meet Again," or "I'll Be Seeing You," which took on new meaning with the separations of wartime. The iconic Broadway show and movie *On the Town* captured the joy and excitement of three sailors on twenty-four-hour liberty in New York City. Their adventures wove together romance and music on the great stage of New York, where getting hijacked by a female taxi driver (men were in short supply) and falling for "Miss Turnstiles of the Month" (a subway pin-up girl) were par for the course.

Everyone stepped up when it came to providing support for servicemen and servicewomen. The Red Cross's three thousand volunteers served more than three million cups of coffee, three-and-a-half million doughnuts, and one-and-a-half million candy bars to departing troops at the New York Port of Embarkation. For soldiers who had

Times Square was the center of popular entertainment both before and during the war, housing the greatest concentration of theaters and movie houses in town.

not yet left, the USO worked nonstop to provide food and entertainment, and, as the *New York Times* reported, "bring women closer to their male loved ones in spirit. As senior hostesses immersed themselves in USO activities, they could comfort someone else's son or spouse in the same way they hoped someone was comforting theirs."

The Fourth Avenue and 93rd Street USO in Brooklyn was typical of those throughout the city. Operated by the Jewish Welfare Board, it relied on volunteers to serve an average of fourteen thousand men a month who flocked to the 5:30 p.m. events and free coffee, cake, sandwiches, milk, punch, and candy. Upwards of one-hundred-fifty women also handed out movie tickets and passes to radio broadcasts, and provided craft courses and tutoring. At the USO events, female volunteers kept track of who was there and kept in touch with the families of servicemen. "We ask for their names and addresses and those of their nearest relatives," said Mrs. Samuel Schimmel, a volunteer. "Then we write them and say we saw their boy and add any message he cares to give." Soldiers relied on the hospitality of the USO for more than food: "The shower and the shave are what I like," said one soldier. "It's swell." Officers had better accommodations, such as the Endicott Hotel, along Columbus Avenue between 81st and 82nd Streets, which catered to Navy officers.

The Stage Door Canteen, on West 44th Street in Times Square, hosted as many as three thousand soldiers each night and was the most famous servicemen's venue in

The USO and Travelers Aid Society operated servicemen's lounges at Grand Central Terminal and Pennsylvania Station, where soldiers could receive information and tickets to wholesome entertainment, lodging, and attractions throughout the city.

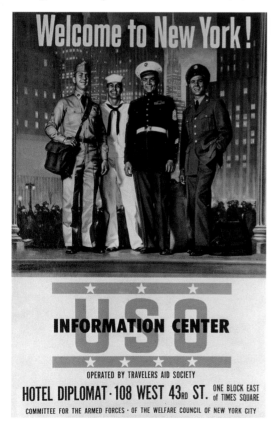

Welcome to New York!

★ ★ ★
USO
INFORMATION CENTER
★ ★ ★ ★

OPERATED BY TRAVELERS AID SOCIETY
HOTEL DIPLOMAT · 108 WEST 43RD ST. ONE BLOCK EAST of TIMES SQUARE
COMMITTEE FOR THE ARMED FORCES · OF THE WELFARE COUNCIL OF NEW YORK CITY

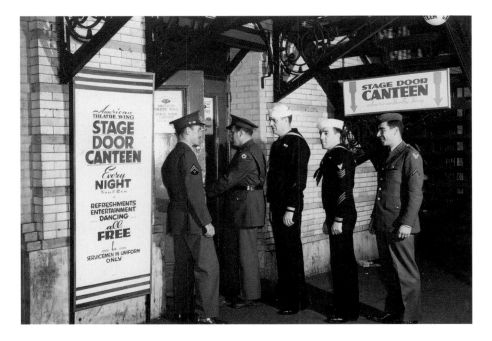

the United States. Run by the American Theatre Wing, the canteen was staffed by film, radio, and theater stars, who served food or even washed dishes for no pay. The Stage Door Canteen was where a lonely young soldier from the heartland could talk with a girl his age and dance with her cheek-to-cheek. As actress Jane Cowl proclaimed, "These men are going to the Philippines. They are going to the Burma Road. Nothing is too good for them."

For those soldiers who did not have someone waiting at home, New York provided a fertile ground for wartime romance. Couples who met on the street or at a station or a canteen sometimes fell suddenly and hopelessly in love. Some were able to short-circuit military regulations and get married without permission. Short engagements and long marriages were commonplace during World War II. It was said that a man and woman would meet on Thursday, fall in love on Friday, marry on Saturday, conceive on Sunday, and say farewell on Monday when the serviceman had to return to his ship or his unit. In the case of a "good-bye baby," the paycheck of the soldier was proportionately

Above:
Soldiers and sailors line up outside the Stage Door Canteen. One of the few racially integrated clubs in the city, the Canteen entertained thousands of soldiers, whatever their race.

Following pages:
Irving Boyer captured the raucous, sensual mood of the wartime city, recreating a scene he glimpsed from a train at the Prospect Park BMT station.

Collection of the New-York Historical Society. Gift of Selwyn L. Boyer, from the Boyer Family Collection, 2002.49

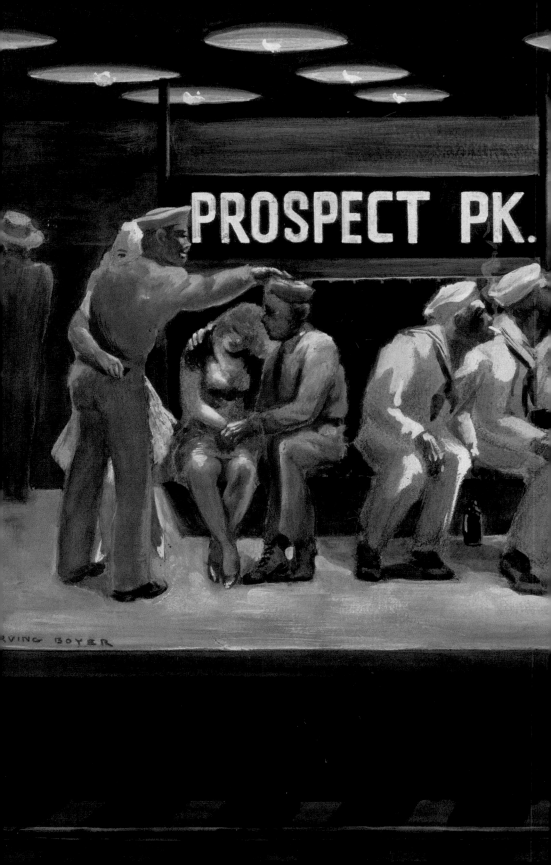

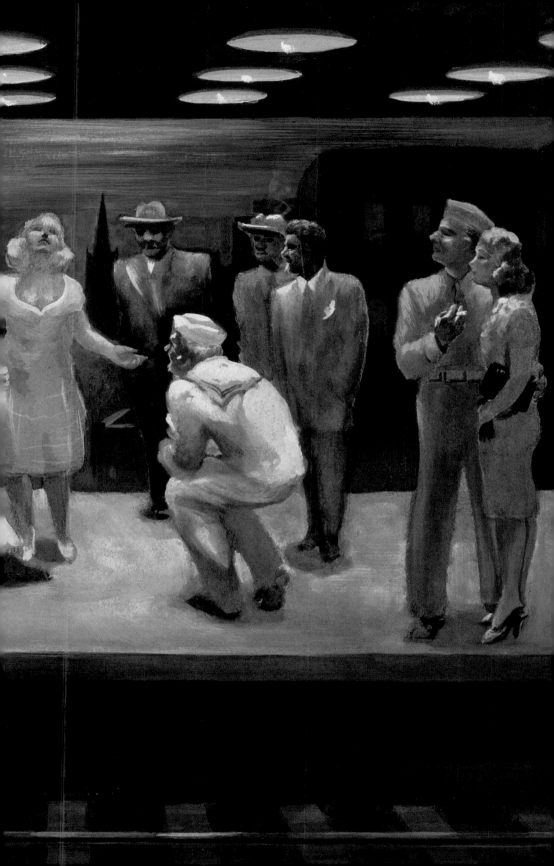

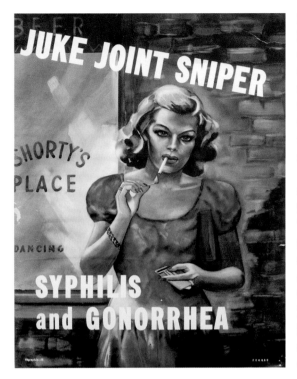

increased to support a family. Such wartime romances could last half a century. Most soldiers, of course, did not find a soul mate during their short time in New York. For them, the famous sites of Manhattan provided all the excitement they needed.

For those little interested in romance, the city's allure included its seamier sides. Young soldiers often wanted sex, and the city had plenty of it. Prostitution had been common in New York since the seventeenth century, but its prevalence increased during World War II as thousands of young men, far from home, wandered the city in search of companionship. Although

The U. S. government waged a campaign against venereal disease among members of the armed forces by issuing unambiguous posters such as this, which warned servicemen of the consequences of unprotected sex.

brothels were illegal and could not advertise, soldiers and sailors were resourceful and determined. One red-light district, the "Barbary Coast," was just outside the Sands Street gate at the Brooklyn Navy Yard. So concerned was the city that in early 1942 the Police Department established a squad to suppress gambling, prostitution, and vice in areas near military and naval concerns, and districts filled with soldiers and sailors on leave. Noting in 1943 that an "increase in promiscuous women and young girls who follow service men seems to be our big problem today," the police department campaigned to slow the rampant spread of venereal disease. This was a national issue as well, and the War Department continually bombarded servicemen with pamphlets, movies, posters, and lectures warning of the dire consequences of V. D. and the danger of consorting with prostitutes.

Creating Rosie the Riveter

During the war years women served as volunteers, dance partners, and shore leave flings, and they were a critical addition to the work force as well. "Rosie the Riveter" became the symbol of the working women of World War II. Wearing trousers and work clothes with sleeves rolled up, New York's women took up the mantle of industry, one they had long been excluded from prior to war. "These women are not makeshift substitutes for men," said New York's port commander, Major General Homer Groninger. "They are doing forty types of jobs and doing them splendidly.' At first, women took jobs as clerks, cabbies, truck drivers, waitresses, ambulance crews, streetcar conductors, and filling station attendants. But as men left for war, women went into factories and shipyards to operate machinery, weld, and do everything necessary for the production of war materiel. "It's not any harder than housework,"

Female riveters work at Grumman Aircraft in Long Island. During the war, women made up twenty-eight percent of the metropolitan-area workforce.

said one woman. In 1941, for example, only one-hundred-twenty women worked at the Brooklyn Navy Yard, almost all as seamstresses. By 1945, the facility employed more than forty-six hundred. In the city as a whole, the federal War Production Board reported in February 1944 that one-hundred-thirty-four thousand women were employed in Gotham's 341 major war plants, about twenty-eight percent of the workforce. After the Axis surrender, most women lost these jobs to returning G.I.s, but wartime experience laid the groundwork for increased gender equality in the workplace.

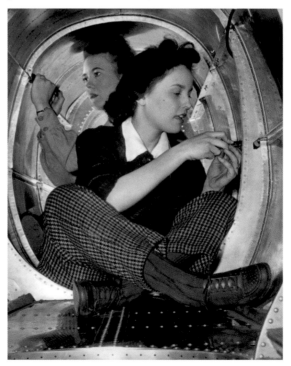

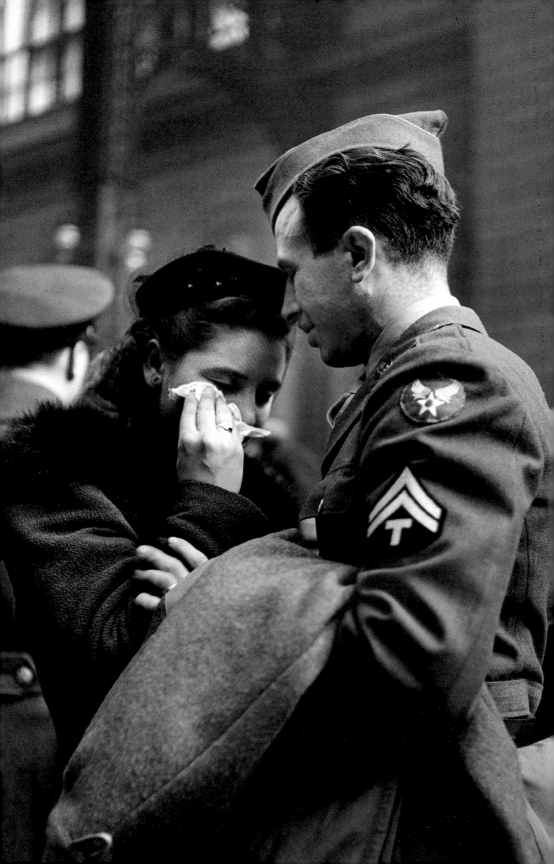

Crossing the Atlantic Ocean

Most servicemen who passed through New York were there because the great harbor was their last stop in America. Inevitably, the city was a place for tearful farewells. Good-byes to loved ones had often taken place weeks or months earlier. But sometimes a wife or mother had followed her soldier to the port of embarkation. Since the piers were closed to visitors, Pennsylvania Station and Grand Central Terminal were more often the places of separation. Such moments of quiet sadness were followed by months, and more likely years, of loneliness.

One teacher from Westby, Wisconsin, left her infant daughter with relatives and journeyed by train to New York to meet her husband for a three-day stay at the St. Regis Hotel, where the Navy had reserved rooms for offi-cers. They saw the sights and heard Bing Crosby perform. On her last afternoon in the city, Vienna James left with a busload of wives for Perth Amboy, New Jersey, where ships of all sizes were massing to form a great convoy. Women stood at the dock crying and waving white handkerchiefs as they watched the great smoky forms in the fog move slowly out to sea. James's husband returned home two years later, and they remained happily married for more than seventy years. Many others did not share their good fortune.

Aboard the troopships themselves, the only things a soldier could bring with him were a duffle bag, a helmet, and a rifle. At the North River Terminal on the Hudson Riv-er, the loaded vessels would join a queue in the harbor and wait until about sixty or seventy similar ships could sail together in a compact formation of approximately twenty square miles—about the area of Manhattan. Then, one evening, without lights and under cover of darkness, the troop carriers and cargo vessels, laden with goods from the New York Port of Embarkation terminals, would slip out into the North Atlantic, protected by a screen of destroyers and sometimes a cruiser or a battleship with much bigger guns. After 1943, escort aircraft carriers called "baby flat-

Opposite:
Alfred Eisenstaedt, a staff photographer at *LIFE* magazine for nearly forty years, captured the farewell embrace of an Army Air Forces corporal and his wife at Penn-sylvania Station.

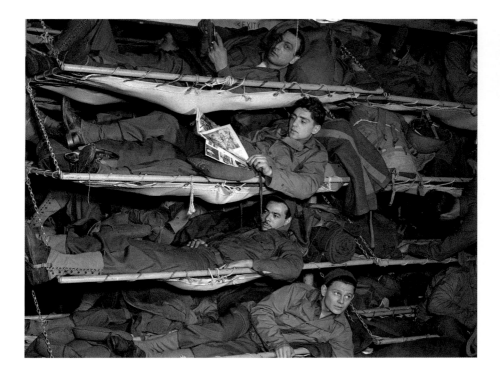

In typically crowded conditions aboard a troopship in New York Harbor, American soldiers await transport overseas.

tops" provided air cover for the convoys. Over time and at great cost of men, money, and materiel, the convoy system, vital for getting troops and supplies to the battlefront, was perfected. This intricate system—and the entire wartime harbor—was administered from the Whitehall Building at 17 Battery Place in lower Manhattan, overlooking Upper New York Bay.

Not every ship went in a convoy. A few huge ocean liners, prominent among them the *Queen Elizabeth* and *Queen Mary,* crossed alone because their speed allowed them to outrun enemy submarines. The ships' hulls were painted black and the superstructures and funnels painted gray. Anti-aircraft guns were installed across the deck, and external degaussing coils were fitted around the hulls to protect them from magnetic mines. Such war fittings meant that each ship could carry more than twelve thousand soldiers, far more than any other vessel afloat. In fact,

in December 1942, the *Queen Mary* set a record by carrying 16,302 soldiers, about equal to an entire infantry division, in a single crossing. Over the course of their wartime service, the *Queen Elizabeth* and *Queen Mary* would take seven-hundred-fifty thousand and six-hundred-fifty thousand men respectively to the battlefields of the war, or almost half of all the men who saw action in the European Theater.

Whether aboard an ocean liner or an ordinary troop transport, soldiers on transatlantic wartime voyages were crowded and uncomfortable, and their futures were uncertain. Those who sailed in the early troopship departures from New York likely took part in Operation Torch, intended to gain complete control of North Africa from the Atlantic Ocean to the Red Sea. Landing in Casablanca on November 8, 1942, under the command of then Major General George S. Patton, the Americans pushed east in the direction of the Suez Canal as the British moved west from Egypt. The objective was to squeeze German Field Marshal Erwin Rommel's renowned Afrika Korps from two directions. This was achieved at Tunis in May 1943, when the Germans and their Italian allies surrendered.

That summer, Dwight D. Eisenhower, commander of all Allied operations in the Mediterranean Theater, moved against Sicily and the Italian mainland. On July 9, 1943, a joint British and American force invaded Sicily, which fell in less than five weeks. The Italian campaign proved to be more difficult. Although the Allies invaded on September 3, 1943, they could not push the German Army out of the country before the end of the war.

The big prize, however, had always been an invasion of northern France followed by a direct thrust into the heart of the Third Reich. By January 1944, General Eisenhower had been appointed Supreme Commander of the Allied Expeditionary Forces for the invasion across the English Channel. Even before January, however, packed troopships from the United States had been discharging their human cargoes in England. The buildup of men, airplanes, tanks, and guns continued for months until it seemed as if the

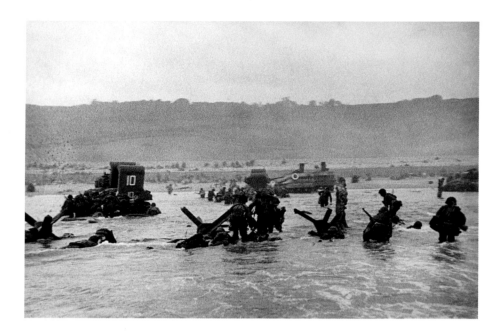

On D-Day, June 6, 1944, American soldiers stormed Omaha Beach in Normandy, France.

island nation might sink from the combined weight of the soldiers and military hardware.

On the evening of June 6, 1944, New Yorkers joined other Americans around their radios to hear President Roosevelt announce that the invasion of Europe had begun. He asked his listeners to join him in prayer for "our sons, pride of our nation," who were being put in harm's way. Over the next eleven months, tens of thousands of American soldiers would be killed in action as the Allies fought their way through France, the Low Countries, and into Germany itself. The *Führer* committed suicide in his bunker in Berlin on April 30, 1945, and the German High Command surrendered at Eisenhower's headquarters one week later. Perhaps never in history has a general's final report on a military campaign been so brief and succinct. Eisenhower's message in full read: "The mission of this Allied Force was fulfilled at 0241, local time, May 7, 1945."

New Yorkers were ecstatic when they heard the news at 9:35 a.m. on May 7. Workers celebrated in the streets in collective relief. Even before dark, bars and restaurants

in Times Square had run out of beer. The streetlights and neon signage of the city had been dimmed since May 18, 1942. With the surrender of Germany, the neon came back on, and huge signs reminded onlookers of Pepsi-Cola, Four Roses, Colgate, and hundreds of other consumer goods that soon would be available again.

President Roosevelt was not alive to celebrate the collapse of Nazi Germany. Although the health of the commander-in-chief had been deteriorating, his death in Warm Springs, Georgia, on April 12, 1945, stunned the nation. Even in thriving New York City, life almost stopped.

On the day victory was declared in Europe, millions of civilians and soldiers thronged Times Square in celebration.

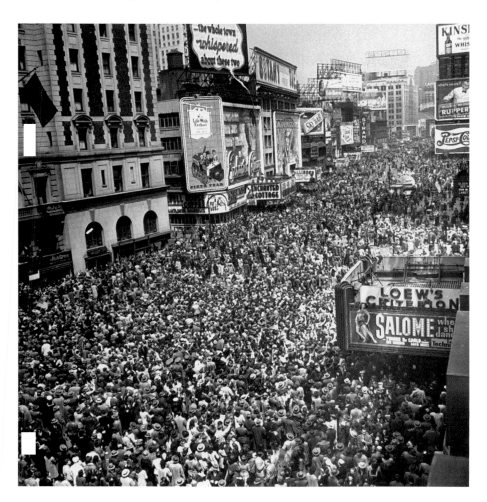

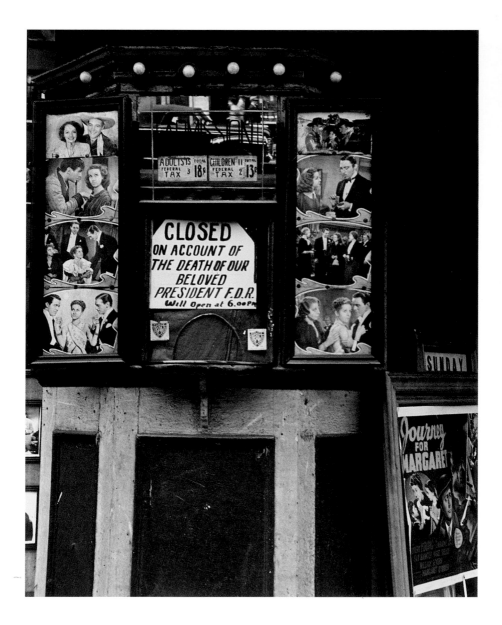

Firehouses sounded their sirens. At Carnegie Hall, the New York Philharmonic canceled its scheduled program and instead played the "Funeral March" from Beethoven's *Eroica* symphony and Richard Strauss's "A Hero's Life." Radio City Music Hall's matinee performance was halted. Nightclubs and theaters closed. Three days later, on the morning of April 15, Roosevelt's funeral train pulled into Pennsylvania Station en route from Washington to the president's home at Hyde Park, New York, seventy-five miles north of Manhattan.

Meanwhile, on the other side of the world, Japan was being battered by relentless air and sea attacks. The end of the most destructive conflict in human history was near. Iwo Jima fell in March 1945, and Okinawa finally gave up on June 21. By July, Japan's entire fleet had been sent to the bottom of the ocean, and its air defense had collapsed. Meanwhile, American B-29 bombers were leveling Japanese cities, even as battleships of the United States Navy began shelling the home islands. On August 6, a single U. S. Army Air Forces B-29 dropped an atomic bomb on the city of Hiroshima. Three days later, a similar fate befell Nagasaki. The atomic age had arrived and, with it, the end of the war.

Coming Home

At 7 p.m. (Eastern War Time) on August 14, 1945, radio stations across the United States interrupted normal programming for President Harry S. Truman's announcement of the surrender of Japan. It was an unforgettable moment for those who experienced it. World War II was over. Across the nation, Americans gathered to celebrate their victory. Spontaneous cheers, horns, sirens, and church bells transmitted the news to every household and hamlet, making known even to small children that it was a very special day. The greatest celebration, however, occurred in the greatest city. In New York, by 10 p.m. more than two million people had converged on Times Square as if it were

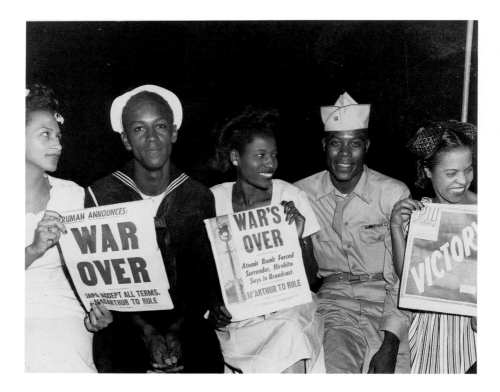

Above:
During the war, Austin Hansen served in the Navy as a photographer's mate, a job usually closed to African Americans at the time. He snapped this photo of a group of men and women celebrating in Times Square.

Opposite:
Following the announcement of the Japanese surrender, Alfred Eisenstaedt took this photo of an impromptu Times Square kiss between an anonymous sailor and nurse.

New Year's Eve. As much as any image, the euphoria of the day was captured by Alfred Eisenstaedt's photograph of a sailor passionately kissing a nurse whom he had never met.

To the average person, the most important consequence of victory was not the end of shortages, nor the restructuring of international boundaries, nor even reparations payments or big-power politics, but the survival of husbands and sons. Normal life could resume. The long vigil was over. The men would be coming home.

The great harbor of New York became the principal port through which returning servicemen passed before boarding trains and buses for the journey home. The trip and the process were agonizingly slow. It had taken years to move sixteen million uniformed personnel around the country to military installations and around the world to the battlefronts. It would take time to bring them back. Returning soldiers crowded onto the *Queen Mary* and the

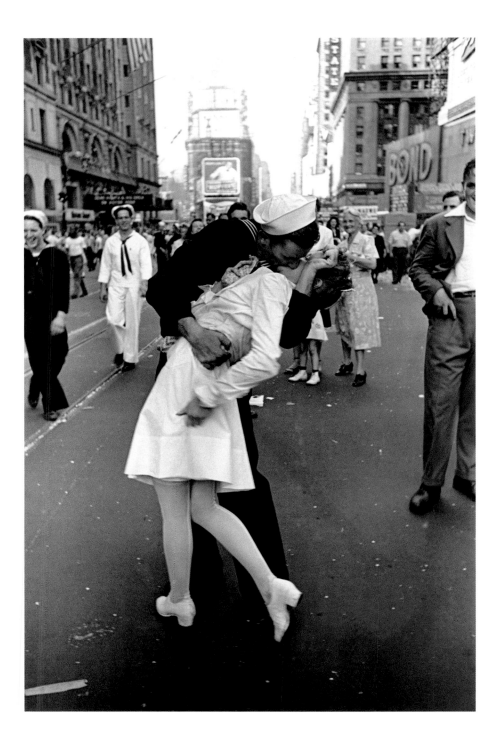

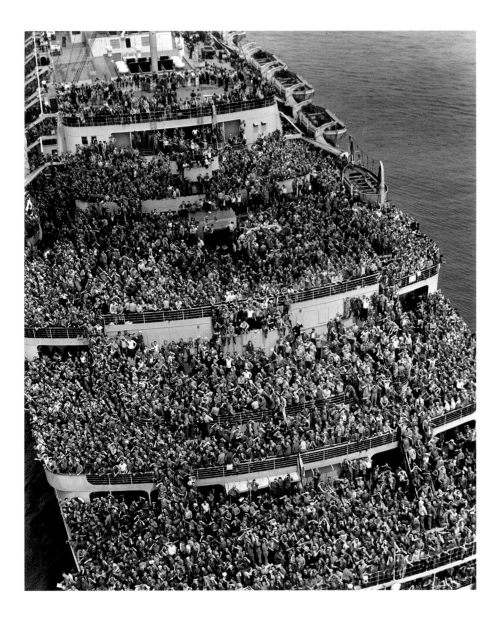

Queen Elizabeth and boarded transports until there was no more room. They would have been willing to stand all the way across the ocean, just to get home a few days earlier.

Just weeks after V-E Day, the men started coming home. On May 29, 1945, ten thousand soldiers—the largest contingent up to that point, and almost half of them wounded—arrived on five ships in New York. The USAHS *Charles A. Stafford* docked at Staten Island carrying 671 patients. The 401st WAC band from Fort Hamilton cheered them on by playing "Hold That Tiger" and "Ac-cent-tchu-ate the Positive." The transports *Santa Rosa* and *Thomas H. Barry* also docked at Stapleton, discharging 4,225 troops. And the transports *George W. Goethals* and the *John Ericcson* docked at Pier 84, at West 44th Street, discharging 5,674 servicemen. All were greeted by bands, by crowds whistling and saluting, and by coffee, milk, doughnuts, and candy bars.

The *Barry* had the distinction of carrying the first war brides to New York City since V-E day, according to the Army Transportation Corps, which arranged their voyage. Captain Norman Angel met his wife, Joy, from Leicester, England, at a dance while he was on a four-day leave. They didn't marry right away because Angel was shot down over Europe and taken prisoner by Germans. He then escaped, got back to England in August 1944, and married Joy.

Thereafter, the transports came in droves. For example, five troopships, led by the *Queen Elizabeth* with 14,810 aboard, sailed into the harbor on August 11, 1945, days before Japan surrendered. As the great liner came through the Narrows and into the Upper Bay, a cheer went up from the homesick soldiers as the Statue of Liberty appeared on the port side, with fireboats shooting water into the air. New York had been the last place they had seen when they had departed, and the famous skyline of Manhattan was the first thing they saw when they returned to American soil. Waiting at the piers were bands and cheering onlookers.

Opposite:
Packed with soldiers, a troopship returns to New York Harbor.

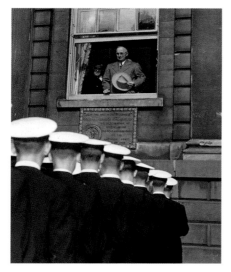

General James M. Gavin's daughter Barbara recounts a moving scene as her father awaited his returning troops. As USO entertainer Martha Tilton sang, "the gangplank was lowered, and the first soldier ran down into the welcoming arms of a young woman. The same scene was repeated over and over as soldiers were reunited with their loved ones for the first time in almost three years." But welcoming gestures were sometimes in short supply. Tuskegee Airman Alexander Jefferson recalls the joy of entering New York's harbor, with "ship's horns...blasting and all of us...shouting at the top of our lungs. Spirits soared when the skyline of New York came into focus, and rose even higher when we spotted the Statue of Liberty... What a feeling of indescribable jubilation! But then, going down the gangplank, a short, smug white buck private shouted, 'Whites to the right, niggers to the left.'"

New Yorkers continued the celebration for months afterward. Returning troops were showered with tons of confetti as they marched under billowing flags up Broadway. In June 1945, the city hosted a ticker-tape parade for General Eisenhower after his return to the United States. That October, millions lined the Hudson River to watch President Truman review a long line of battleships and aircraft carriers that had just returned from Japan. And on January 12, 1946, the proud 82nd Airborne Division, which had parachuted behind German lines before dawn on D-Day, marched up Broadway to another thunderous ticker-tape homecoming.

We Will Remember Them

There were those who did not come home. More than four hundred thousand Americans lost their lives in the war,

Above:
President Harry S. Truman stands with Mayor La Guardia in City Hall during Navy Day festivities on October 27, 1945.

Opposite:
Jacob Lawrence served in the Coast Guard during the war. *The Letter* captures the tragic news of a death.
Jacob Lawrence (1917–2000), *War Series: The Letter,* 1946. Egg tempera on composition board, 20 x 16 in. Whitney Museum of Art, New York; Gift of Mr. and Mrs. Roy R. Neuberger 51.11. © The Jacob and Gwendolyn Lawrence Foundation, Seattle / Artists Rights Society (ARS), New York

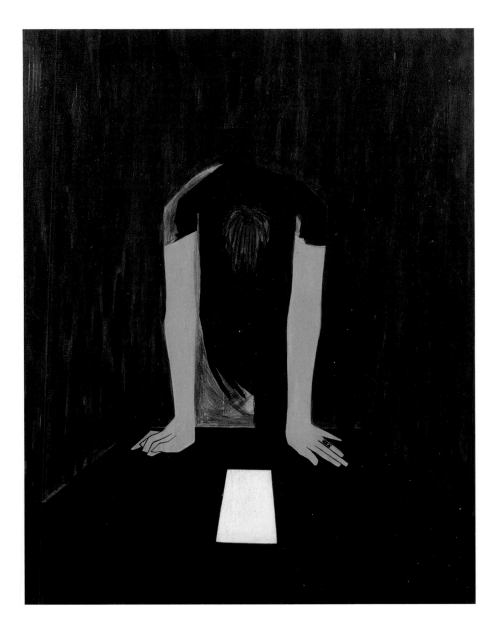

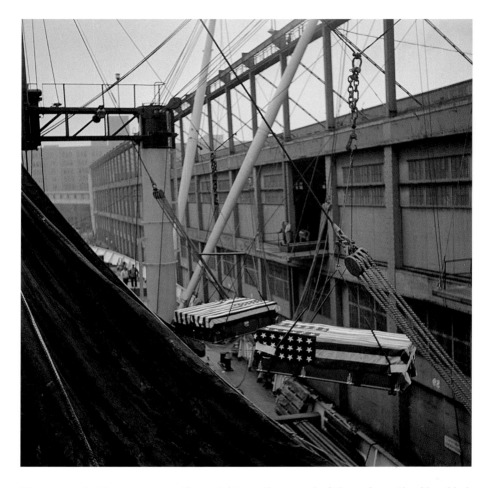

When requested by the next of kin, remains of the war dead were shipped back to New York. In 1947, these coffins arrived at the Brooklyn Army Terminal and were transferred onto Army mortuary trains for the journeys home.

more than eighteen thousand of them from the New York metropolitan region. Some of the stories were particularly poignant. For example, in a small cul-de-sac in suburban Port Chester, New York, eight boys who had grown up on the same street and attended the same schools and churches were killed in action in separate incidents. To the people who loved them, all of the American dead were heroes.

One of the greatest hometown heroes was John Basilone of suburban Raritan, New Jersey. At Guadalcanal during the Battle of Henderson Field in October 1942, the sergeant's unit defended the airfield against a fero-

cious all-night Japanese attack. Under heavy fire, all but two of the men in a critical defensive position were killed or wounded. Basilone moved to the exposed flank, single-handedly positioning, repairing, and manning a gun until replacements arrived. Then—alone—Basilone made two trips under sniper fire to resupply his men. The next morning, astonished American officers discovered that Basilone's unit had killed more than twenty-nine hundred Japanese who had tried to capture their position, and Basilone became the first enlisted marine in World War II to win the Medal of Honor. Ordered home to help raise money for war bonds, Basilone was fêted throughout the metropolitan region. He was received in New York City by Mayor La Guardia and was the guest of honor at an elaborate event in New Haven hosted by the governor of Connecticut. But he asked to rejoin the fighting, and on February 19, 1945, he was in the first wave of marines to invade Iwo Jima. After single-handedly destroying a fortified position from which the Japanese fired against the beachhead, Basilone guided an American tank safely through a minefield before being killed by mortar shrapnel. For his actions, he was posthumously awarded the Navy Cross and the Purple Heart.

World War II and the Transformation of New York

The national effort to defeat the Axis threatened the economic preeminence of America's largest city. The building of vast military bases in the South and West led to a demographic shift toward California, Texas, Florida, Georgia, and North Carolina that would undermine the Empire City's status as the most important industrial center in the nation. Similarly, important postwar federal initiatives such as the GI Bill, the Federal Housing Administration, and the Veterans Administration led to a population surge in the suburbs. For example, Levittown, which was developed in the late 1940s on four thousand acres of Long Island potato fields, became the largest housing development ever put up by a single builder. Ultimately consisting of nearly sev-

Above:
After the war, Levittown, Long Island, became the quintessential middle-class tract suburb, and its first houses were let specifically to veterans. African Americans, however, were not allowed to rent homes there.

Opposite:
New York became the center of a huge expansion in white-collar employment, and modern, glass-walled skyscrapers such as Lever House were built to house the boom.

enteen-and-a-half thousand separate houses and eighty-two thousand residents, Levittown served the American dream-home market at close to the lowest prices the industry could attain. From the perspective of New York City, however, the news was less positive. Hundreds of thousands of middle-class families left the five boroughs for a new life on the metropolitan fringe. Many never came back.

New York City also lost industry as a result of World War II. Although factories had been moving to the suburbs since at least 1868, when the Singer Sewing Machine Company left New York City for suburban Elizabeth, New Jersey, industrial employment was still concentrated in inner cities in 1940. Along the East and Hudson Rivers were miles of factories and warehouses. But wartime changed the industrial landscape. With factory expansion difficult in crowded urban areas, the federal government invested funds elsewhere. For example, Washington subsidized new

textile mills in the South to make military uniforms—far from the longtime center of garment production in Manhattan. Although it was America's greatest industrial city by total output, New York was at a competitive disadvantage to its peers due to its preponderance of small manufacturers, highly unionized labor force, and focus on non-durable consumer goods—not the heavy manufactures needed for war production. Government contracts were disproportionately awarded to highly capitalized, non-union producers outside the Northeast, and, as late as 1942, unemployment in New York remained at Depression-era levels, with an estimated four hundred thousand city residents without work. The city did recover and added more than three hundred new plants by 1943, but the city's old factories could not compete with more modern facilities across the Sun Belt—or their cheaper labor forces. At war's end, the seeds of New York's swift deindustrialization had already been laid.

At the same time, federal and state subsidies to the automobile industry helped make the deconcentrated lifestyle of the suburbs more possible. The congested city, with its creaky subways and loft buildings, seemed old-fashioned. Not surprisingly, New York City continued to lose industrial jobs for the remainder of the century and by the turn of the twenty-first century was no longer even a major producer, let alone the greatest industrial city in the world.

But New York did not wither as it lost citizens to the suburbs and factories to the South. Rather, it reconstituted itself as a different kind of metropolis. As the *New York Herald Tribune* had predicted in 1943, even as the city lost its industrial primacy, it gained in the white-collar boom that followed the end of the war. The huge postwar expansion of managerial and professional occupations jump-started New York's transformation from the world's great manufacturing city into the world's great professional-services city, whose economy would come to be dominated not by garment-making and printing, but by corporate headquar-

ters, investment banks, law firms, insurance companies, and—arguably the city's original business—real estate.

Finally, New York benefited from the global conflict because unlike Berlin, Tokyo, Vienna, London, Paris, and Rome, it escaped occupation, bombardment, and impoverishment. Paris, which had been the world's undisputed cultural capital for a generation, under the Nazis lost the critical mass and creative energy that had made it a magnet for the cultural elite. In its place, New York emerged at the vanguard, where the confluence of talent, media, and money transformed the city into the cultural capital of the postwar world. The city also gained from the human tide of refugees and displaced persons that the war created. When Hitler's racist policies drove Jewish scientists and intellectuals out of German-occupied territory, Gotham recalled its immigrant heritage and welcomed them. And when a new international body—the United Nations—was formed in 1945, New York became its home.

Without a doubt, New York played a vital role in promoting the war effort through manufacturing, sending troops abroad, hosting them at home, and propelling the war effort. But the war also stimulated vast changes in demographic and industrial trends in the United States. The city's once-dominant position in the national economy began to erode. It was New York's ability to reinvent itself that turned its trajectory around in the late twentieth century, restoring it to its place as the capital of capitalism and the capital of the world.

Opposite:
The United Nations headquarters in Manhattan's Turtle Bay, shortly after its completion in October 1952.

SELECT BIBLIOGRAPHY

Bentley, Amy. *Eating for Victory: Food Rationing and the Politics of Domesticity*. Urbana: University of Illinois Press, 1998.

Bérubé, Allan. *Coming Out Under Fire: The History of Gay Men and Women in World War II.* New York: Free Press, 1990.

Billy, George J., and Christine M. Billy. *Merchant Mariners at War: An Oral History of World War II.* Gainesville: University Press of Florida, 2008.

Biondi, Martha. *To Stand and Fight: The Struggle for Civil Rights in Postwar New York City.* Cambridge: Harvard University Press, 2003.

Brandt, Nat. *Harlem at War: The Black Experience in WWII.* Syracuse: Syracuse University Press, 1996.

Castellano, Nancy Lynch. *Looking Back at the WAVES: A Chronicle of 90,000 Navy Women of World War II.* New Jersey: N. L. Castellano, 2007.

Cohen, Lizabeth. *A Consumers' Republic: The Politics of Mass Consumption in Postwar America.* New York: Alfred A. Knopf, 2003.

Diehl, Lorraine B. *Over Here!: New York City During World War II.* New York: Smithsonian Books/HarperCollins Publishers, 2010.

Freeman, Joshua B. *Working-Class New York: Life and Labor Since World War II.* New York: New Press, 2000.

Gannon, Michael. *Operation Drumbeat: The Dramatic True Story of Germany's First U-boat Attacks along the American Coast in World War II.* New York: Harper & Row, 1990.

Goldstein, Richard. *Helluva Town: The Story of New York City During World War II.* New York: Simon and Schuster, 2010.

Gurock, Jeffrey. *Jews in Gotham*. Vol. 3, *City of Promises: The History of Jews in New York,* edited by Deborah Dash Moore. New York: New York University Press, 2012.

Hegarty, Marilyn E. *Victory Girls, Khaki-Wackies, and Patriotutes: The Regulation of Female Sexuality during World War II.* New York: New York University Press, 2008.

Jaffe, Steven H. *New York at War: Four Centuries of Combat, Fear, and Intrigue in Gotham*. New York: Basic Books, 2012.

Keegan, John. *The Second World War.* New York: Viking, 1990.

Kelly, Cynthia C., ed. *The Manhattan Project: The Birth of the Atomic Bomb in the Words of Its Creators, Eyewitnesses, and Historians.* New York: Black Dog & Leventhal, 2007.

Kennedy, David M. *Freedom From Fear: The American People in Depression and War, 1929–1945*. New York: Oxford University Press, 1999.

Kisseloff, Jeff. *You Must Remember This: An Oral History of Manhattan from the 1890s to World War II*. New York: Harcourt Brace Jovanovich, 1989.

Lax, Eric. *The Mold in Mr. Florey's Coat: The Story of the Penicillin Miracle*. New York: Henry Holt, 2004.

Lingeman, Richard R. *Don't You Know There's a War On?: The American Home Front, 1941–1945*. New York: G. P. Putnam's Sons, 1970.

Meany, Joseph E., Jr. "Port in a Storm: The Port of New York in World War II." In *To Die Gallantly: The Battle of the Atlantic,* edited by Timothy J. Runyan and Jan M. Copes. Boulder, CO: Westview, 1994.

Phillips, Kimberley L. *War! What is it Good For?: Black Freedom Struggles and the U.S. Military from World War II to Iraq.* Chapel Hill: University of North Carolina Press, 2012.

Rendell, Kenneth. *World War II: Saving the Reality: A Collector's Vault.* Atlanta, GA: Whitman Publishing, 2009.

Rhodes, Richard. *The Making of the Atomic Bomb.* New York: Simon and Schuster, 1986.

Rivas-Rodríguez, Maggie, and Emilio Zamora, eds. *Beyond the Latino World War II Hero: The Social and Political Legacy of a Generation.* Austin: University of Texas Press, 2009.

Russell, Harold, and Victor Rosen. *Victory in My Hands.* New York: Creative Age Press, 1949.

Stoff, Joshua. *Picture History of World War II American Aircraft Production.* New York: Dover Publications, 1993.

Wallace, Mike. *Gotham II: A History of New York City from 1898 to 1945* (in progress; to be published by Oxford University Press).

Webber, Scott E. *Camp Shanks and Shanks Village: A Scrapbook.* New City, N.Y. : The Historical Society of Rockland County, 1991.

Weinberg, Gerhard L. *A World at Arms: A Global History of World War II.* New York: Cambridge University Press, 1994.

Winchell, Meghan K. *Good Girls, Good Food, Good Fun: The Story of USO Hostesses during World War II.* Chapel Hill: University of North Carolina Press, 2008.

Wong, K. Scott. *Americans First: Chinese Americans and the Second World War.* Cambridge: Harvard University Press, 2005.

Writers' Program of the Work Projects Administration for the City of New York and Barbara LaRocco. *A Maritime History of New York.* Brooklyn, N.Y.: Going Coastal, 2004.

PHOTO CREDITS

p. 8, top: David Heald, courtesy The Estate of David Smith, New York; bottom: Collection of the New-York Historical Society. Gift of Bella C. Landauer, 2002.1.3897; p. 10, top left and right: Collection of the New-York Historical Society, PR 207, © Andreas Feininger/Bonni Benrubi Gallery; bottom: © Bettmann/CORBIS; p. 12: Collection of the New-York Historical Society, SY1941 no. 101; p. 13: © Bettmann/CORBIS; p. 14, bottom: Collection of the New-York Historical Society, PR 76; pp. 16–17: Collection of the New-York Historical Society, PR 20; p. 18: Courtesy NYC Municipal Archives; p. 19: Collection of the New-York Historical Society, PR 76; p. 22: Collection of the New-York Historical Society, PR 76; p. 23: AP Images; p. 24: John Philip Falter/Library of Congress Prints and Photographs Division, LC-USZC4-2002; p. 26: Architectural Forum/Time, Inc. © Fairchild Aerial Surveys, Inc.; p. 28: Collection of the New-York Historical Society, PR 76; p. 29: National Archives, item UTS 4 #46; p. 30: Courtesy of Pfizer Inc. Archive; p. 31: Collection of the New-York Historical Society, Helen Young collection, D.810 .W7 C65, Series VII, Nov 1943; p. 32, top: Cradle of Aviation Museum, Garden City, N.Y.; bottom: Museum of the Moving Image; p. 34: Dunning Cyclotron, Division of Medicine and Science, National Museum of American History, Behring Center, Smithsonian Institution; p. 35: © Bettmann/CORBIS; p. 36: Photographs and Prints Division, Schomburg Center for Research in Black Culture, The New York Public Library, Astor, Lenox and Tilden Foundations; p. 37: NY Daily News via Getty Images; p. 39: Gift of the Tanenbaum family in memory of David and Rose Tanenbaum, Museum of Jewish Heritage, NY; p. 40: Library of Congress, Prints and Photographs Division, LOT-10640-113; p. 42: Photography Collection, Miriam and Ira D. Wallach Division of Art, Prints and Photographs, The New York Public Library, Astor, Lenox and Tilden Foundations; p. 43: Courtesy of Captain James McNamara; p. 44, bottom: Collection of the New-York Historical Society, PR 55; p. 45: Collection of the New-York Historical Society, Manuscript Collection, World War II; p. 47: Collection of the New-York Historical Society, PR 207, © Andreas Feininger/Bonni Benrubi Gallery; p. 48: Collection of the New-York Historical Society, F128 HV696.T7 C65 1943; p. 49: Billy Rose Theatre Division, The New York Public Library for the Performing Arts, Astor, Lenox and Tilden Foundations; p. 52: Collection of Charles Rosenblum; p. 53: AP Images; p. 54: Time & Life Pictures/Getty Images; p. 56: National Archives, item SC-197698-S; p. 58: © Robert Capa/International Center of Photography/Magnum Photos; p. 59: Time & Life Pictures/Getty Images; p. 62: Austin Hansen Collection, Photographs and Prints Division, Schomburg Center for Research in Black Culture, The New York Public Library. Used by permission of Joyce Hansen; p. 63: Time & Life Pictures/Getty Images; p. 64: Collection of the New-York Historical Society, PR 76; p. 66: Collection of the New-York Historical Society, PR 76; p. 67: photograph by Geoffrey Clements; p. 68: Michael Rougier/ Time & Life Pictures/Getty Images; p. 70: © Bettmann/CORBIS; p. 71: Lever House, 1952. Museum of the City of New York, Gottscho-Schleisner Collection; p. 74: Collection of the New-York Historical Society, PR 215, Robert M. Lester Photograph Collection.

COLOPHON

Published as a companion to the exhibition *WWII & NYC*, October 5, 2012–May 27, 2013.

This edition © 2012 The New-York Historical Society. Text and illustrations © 2012 The New-York Historical Society.

All rights reserved. No part of the contents of this book may be reproduced, stored in a retrieval system, or transmitted in any form or by any means, electronic, mechanical, photocopying, recording, or otherwise without the written permission of the New-York Historical Society and Scala Publishers Ltd.

First published in 2012 by The New-York Historical Society, 170 Central Park West, New York, NY, 10024, USA
www.nyhistory.org

in association with Scala Publishers Ltd., Northburgh House, 10 Northburgh Street, London EC1V 0AT, UK
www.scalapublishers.com

Distributed in the book trade by Antique Collectors' Club Limited, 6 West 18th Street, Suite 4B, New York, NY 10011, USA

Printed and bound in China
10 9 8 7 6 5 4 3 2 1

ISBN 978-1-85759-808-7

Every effort has been made to acknowledge correct copyright of images where applicable. Any errors or omissions are unintentional and should be notified to the Publisher, who will arrange for corrections to appear in any reprints.

For the New-York Historical Society:
Curator: Marci Reaven
Editing, research, and coordination:
 Andrew Kryzak
Editorial staff: Nicole Frisone, Penelope Gelwicks, Clare Richfield, Mike Thornton
Image and rights coordinator:
 Dayna Bealy

For Scala Publishers:
Design: Inglis Design
Project Manager: Eugenia Bell

Front cover: Alfred Eisenstaedt/Time & Life Pictures/Getty Images

Back cover: Collection of the New-York Historical Society, McLaughlin Air Service

Inside cover: Collection of the New-York Historical Society; Gift of Marilyn Moskowitz and Helen Berlin

Furthermore:
a program of the J. M. Kaplan Fund

Published with support from Furthermore: a program of the J. M. Kaplan Fund